HISTORIC PHOTOS OF
MEMPHIS

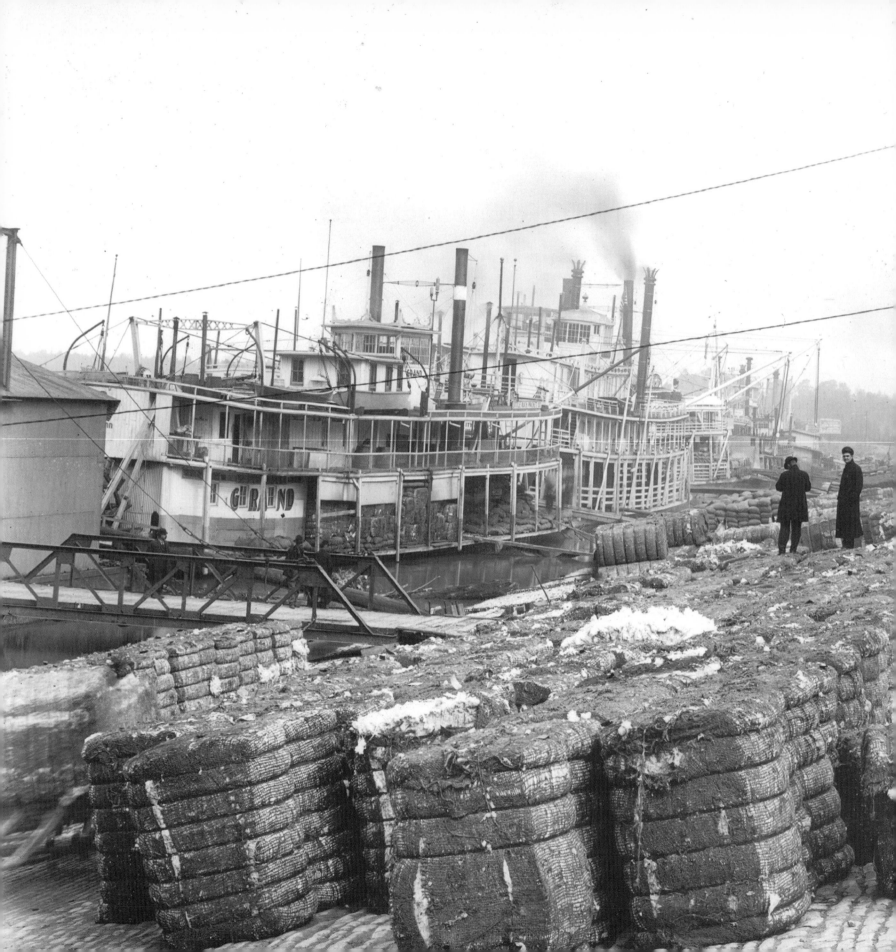

HISTORIC PHOTOS OF
MEMPHIS

Turner
Publishing Company

Nashville, Tennessee • Paducah, Kentucky

Turner Publishing Company
200 4th Avenue North • Suite 950 412 Broadway • P.O. Box 3101
Nashville, Tennessee 37219 Paducah, Kentucky 42002-3101
(615) 255-2665 (270) 443-0121

www.turnerpublishing.com

Library of Congress Control Number: 2006902320
ISBN: 1-59652-261-5

Printed in the United States of America.

0 9 8 7 6 5 4 3 2 1

CONTENTS

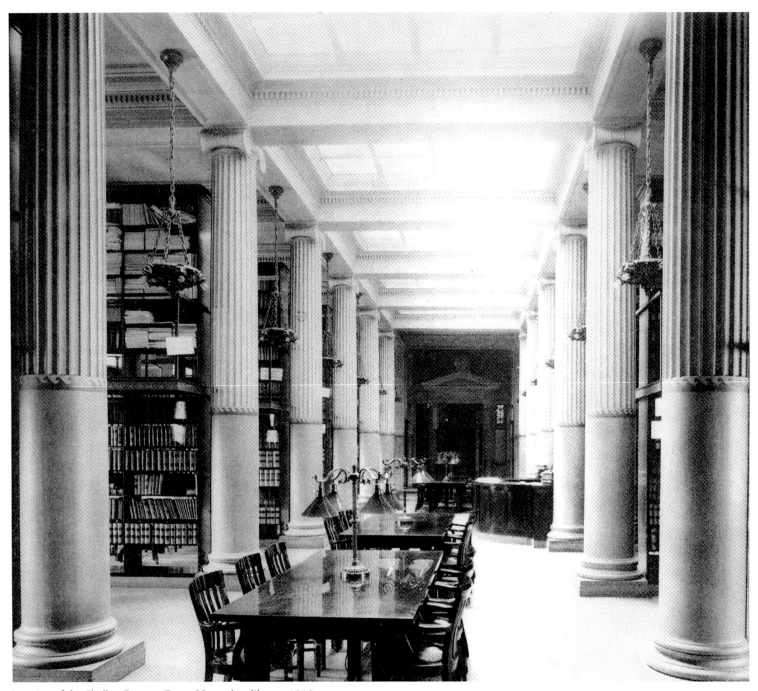

Interior of the Shelby County Court House law library, 1913.

ACKNOWLEDGMENTS

This volume, Historic Photos of Memphis, is the result of the cooperation and efforts of many individuals, organizations, institutions and corporations. It is with great thanks that we acknowledge the valuable contribution of the following for their generous support.

First Tennessee Bank
Memphis Light, Gas & Water
Memphis Public Library

We would also like to express our gratitude to Dr. Wayne Dowdy for providing research and contributing in all ways possible.

And finally, we would like to thank the following individuals for their valuable contribution and assistance in making this work possible:

Dr. Jim Johnson, Memphis and Shelby County Room, Memphis Public Library
Patricia LaPointe, Memphis and Shelby County Room, Memphis Public Library
Dr. Jim Johnson, Senior Manager, History Department
G. Wayne Dowdy, Archivist, History Department
Patricia LaPointe, Curator, Memphis and Shelby County Room
Betty Anne Wilson, Assistant Director for Library Advancement

Kim Cherry, Vice President of Corporate Communications, First Horizon National Corporation

PREFACE

Memphis has thousands of historic photographs that reside in archives, both locally and nationally. This book began with the observation that, while those photographs are of great interest to many, they are not easily accessible. During a time when Memphis is looking ahead and evaluating its future course, many people are asking how do we treat the past? These decisions affect every aspect of the city – architecture, public spaces, commerce and infrastructure – and these, in turn, affect the way that people live their lives. This book seeks to provide easy access to a valuable, objective look into the history of Memphis.

The power of photographs is that they are less subjective in their treatment of history. While the photographer can make decisions regarding what subject matter to capture and some limited variation in its presentation, photographs do not provide the breadth of interpretation that text does. For this reason, they provide an original, untainted perspective that allows the viewer to interpret and observe.

This project represents countless hours of review and research. The researchers and authors have reviewed thousands of photographs in numerous archives. We greatly appreciate the generous assistance of the archivists listed in the acknowledgements of this work without which, this project could not have been completed.

The goal in publishing this work is to provide broader access to this set of extraordinary photographs that seek to inspire, provide perspective and evoke insight that might assist people who are responsible for determining Memphis' future. In addition, the book seeks to preserve the past with adequate respect and reverence.

The photographs selected have been reproduced using multiple colors of ink to provide depth to the images. With the exception of touching up imperfections caused by the damage of time, no other changes have been made. The focus and clarity of many images is limited to the technology and the ability of the photographer at the time they were taken.

The work is divided into eras. The history of Memphis is recorded in some of the earliest known photographs from pre-Civil War to modern Memphis.

In each of these sections we have made an effort to capture various aspects of life through our selection of photographs. People, commerce, transportation, infrastructure, religious institutions and educational institutions have been included to provide a broad perspective.

We encourage readers to reflect as they go walking in Memphis, along the riverfront or through the Peabody. See the riverboats that once lined the Mississippi and many buildings, long since demolished, that lined Front and Main streets. It is the publisher's hope that in utilizing this work, long time residents will learn something new and that new residents will gain a perspective on where Memphis has been, so that each can contribute to its future.

Todd Bottorff, Publisher

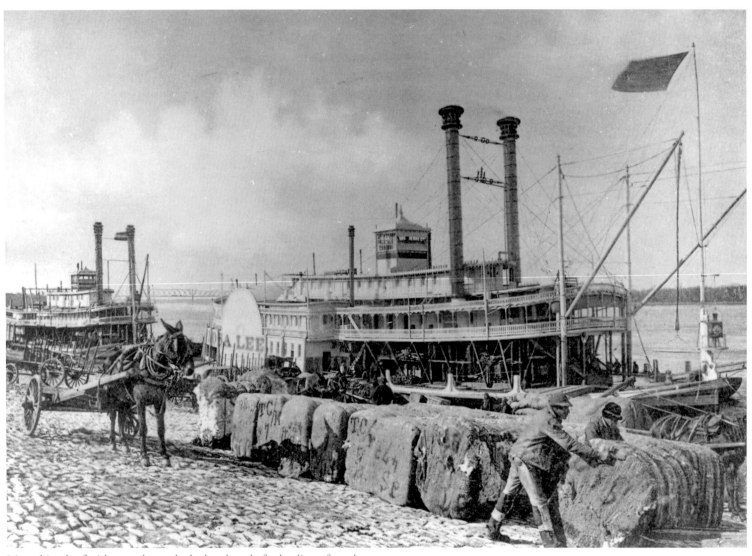

Memphis wharf with steamboats docked and ready for loading of goods.

Pre-Civil War to the Turn of the Century

1860-1899

Memphis had developed considerably because of river trade by the second half of the nineteenth century. The city's commercial importance increased when the Memphis and Charleston Railroad was completed in 1857, linking the Atlantic Ocean and the Mississippi River. The city's population in 1860 was ten times greater than it had been just twenty years earlier largely due to an influx of Irish and German immigrants. Before the Civil War, Memphis was a vibrant and important city.

The city was occupied by Federal forces in June 1862 following the Battle of Memphis. Fortunately, the brief naval engagement left the city largely undamaged and the business community continued to thrive even under occupation. As the city adjusted to life after the Civil War newcomers continued to flock to the city.

Memphis was a haven for thousands of displaced former slaves. Their presence, along with the predominantly African American Federal occupation force, led to a shift in the city's racial makeup causing resentment among many former Confederates. Tensions erupted into a three-day race riot in 1866 leaving many dead and injured. Despite adverse circumstances in the wake of this tragedy, African Americans managed to maintain a foothold in the fabric of the growing city. As time went on, many made social, political and economic advances rarely seen in other Southern cities.

The 1870s were difficult times for Memphis. The city suffered a series of devastating yellow fever outbreaks in the 1860s and 1870s, but the worst outbreak was in 1878. Thousands died, while many others fled the city never to return. Falling property values and reckless management of city finances led the city to declare bankruptcy and to loose its charter in 1879.

The end of the nineteenth century marked a period of renewal for Memphis. In 1880, state-appointed officials took control of the city and cleared debts, improved sanitation and rebuilt the political infrastructure. Cotton and the growing hardwood industry contributed to the economic recovery. Other improvements included the discovery of artesian water in 1887, the construction of the Frisco Bridge across the Mississippi River in 1892 and the first public library in 1893. Also in 1893, home rule for Memphis returned and the South's first African American millionaire, Robert Reed Church, Sr., purchased the first city bond. Memphis continued to grow with the opening of the Porter Building in 1895, which was the city's first modern skyscraper, and the opening of Church's Park and Auditorium, the city's first park and entertainment center for African Americans, in 1899.

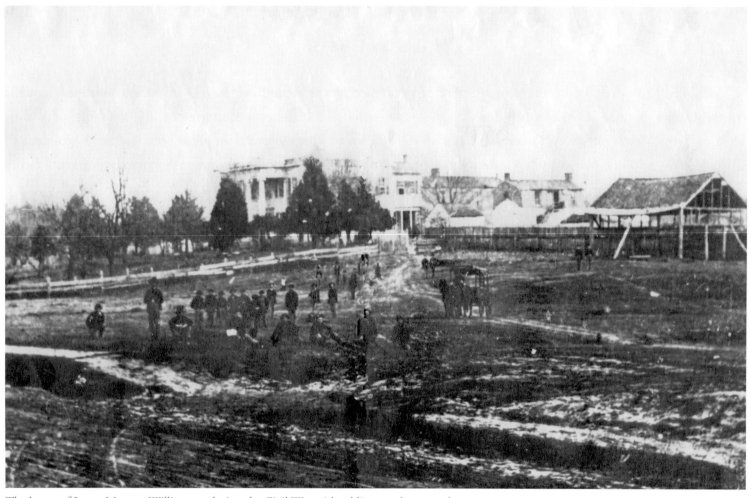

The home of James Monroe Williamson during the Civil War with soldiers on the grounds.

The Hunt-Phelan House. The home was built between 1828 and 1832 on Beale Street and was headquarters to General Leonidas Polk during the Civil War. After the war, the Freedman's Bureau ran a school on the property.

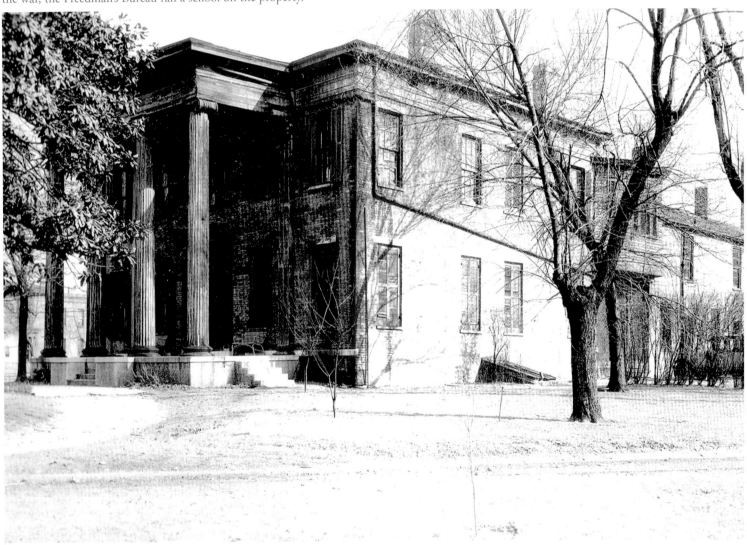

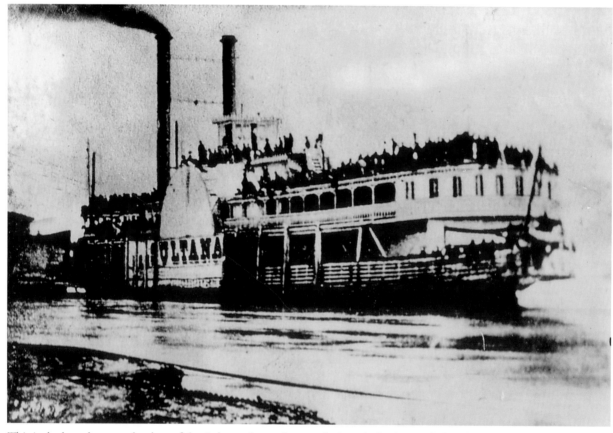

This is the last photograph taken of the *Sultana*. It was destroyed when the boilers exploded shortly after leaving Memphis on April 27, 1865. The sinking of the *Sultana* was the worst maritime disaster in American history.

Frederick H. Cossitt and family, 1884. A gift of $75,000 from Cossitt's estate made the founding of the first free public library in Memphis possible.

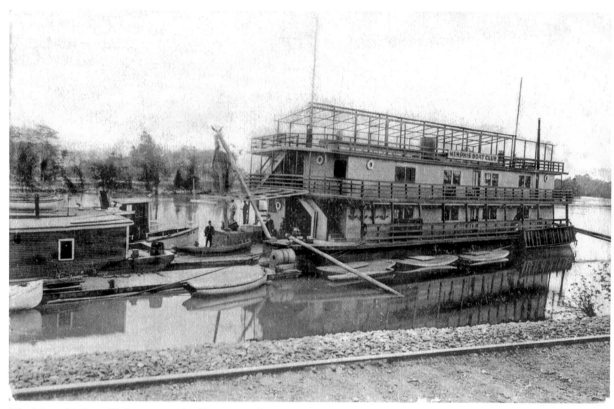

The Memphis Boat Club was organized in 1901 to foster participation in rowing, boating and yachting.

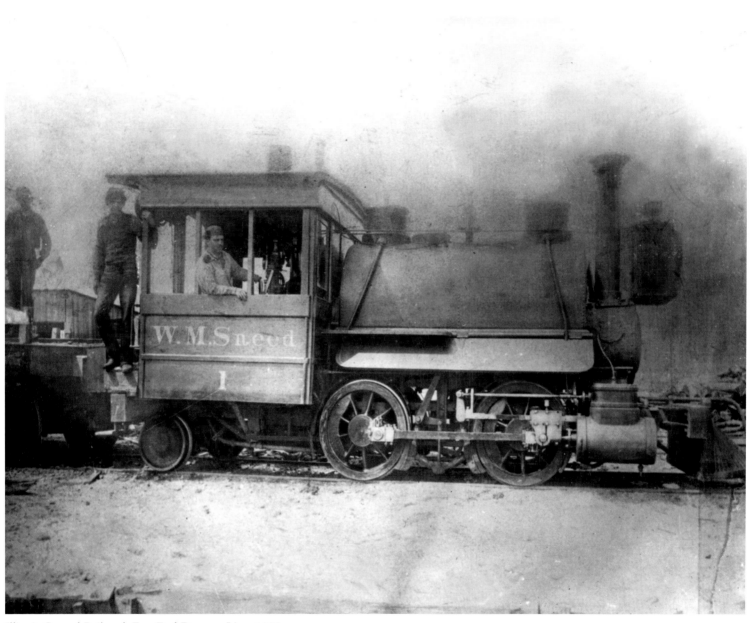

Illinois Central Railroad, East End Dummy Line, 1888.

Equitable Building, 1890s.

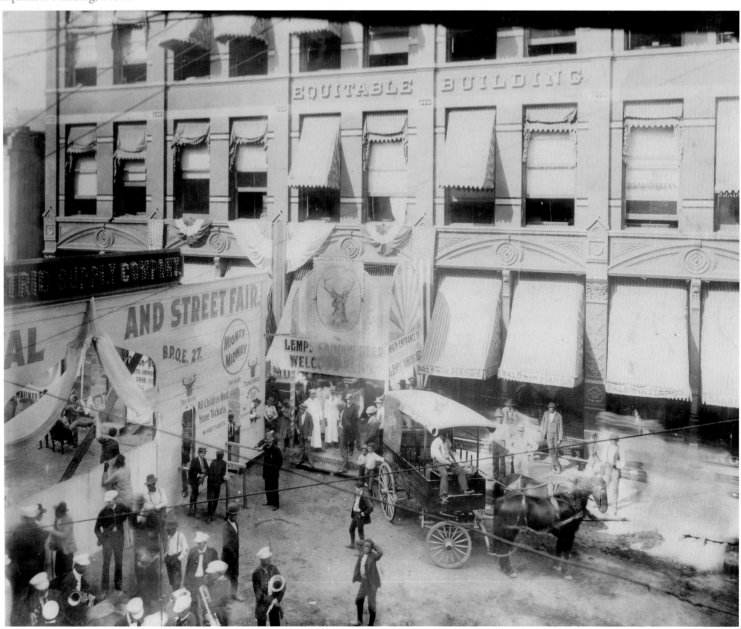

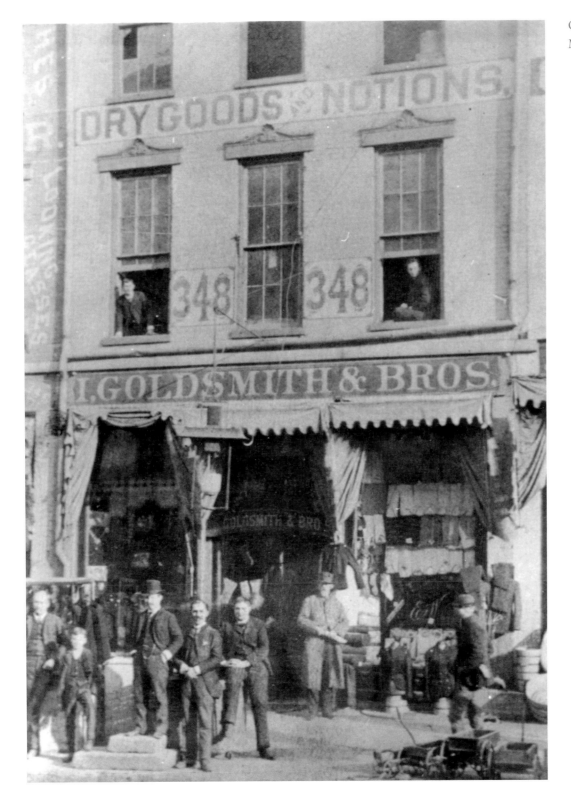

Goldsmith's Dry Goods Store at 348 Main Street, 1880s.

The Great Bridge, later named the Frisco Bridge,
during construction, 1891.

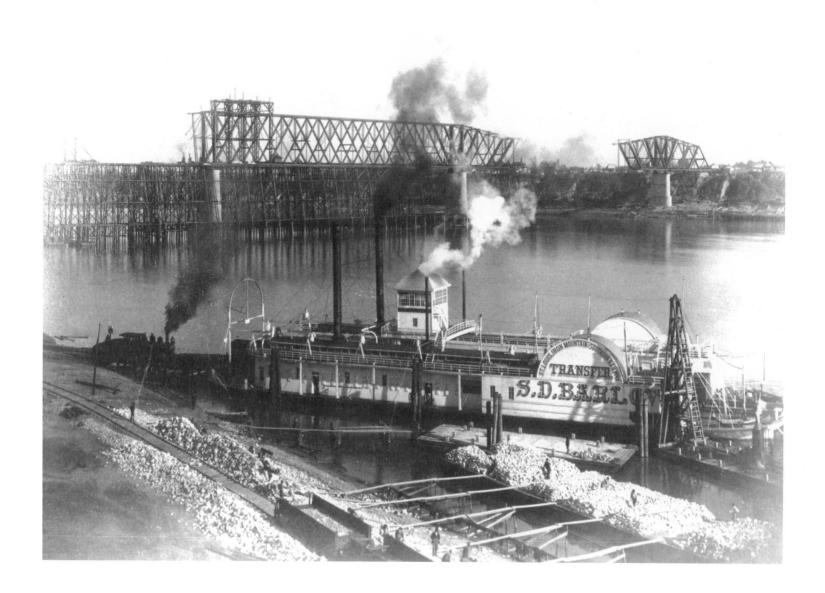

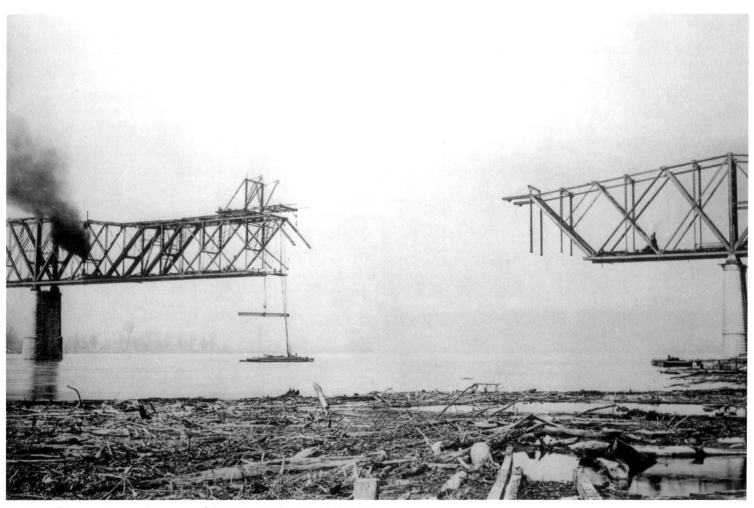

Erection of the east intermediate span of the Frisco Bridge, March 2, 1892.

Belle of the Bends at Memphis, circa 1899.

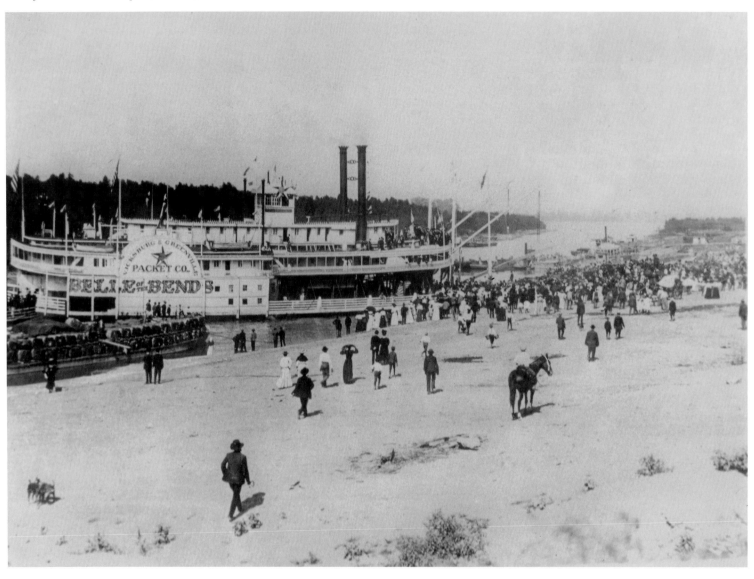

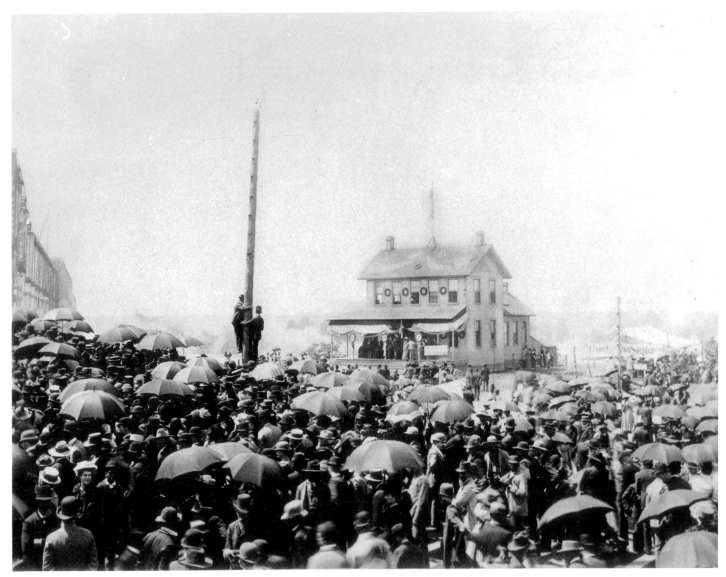

Opening of the Great Bridge at Memphis on May 12, 1892. The bridge was only the second to span the Mississippi River, after the Eads Bridge was constructed at St. Louis in the 1870s. After the bridge was purchased by the St. Louis and San Francisco Railway in 1903, the name was changed to the Frisco Bridge.

Scene from South Memphis, circa 1899.

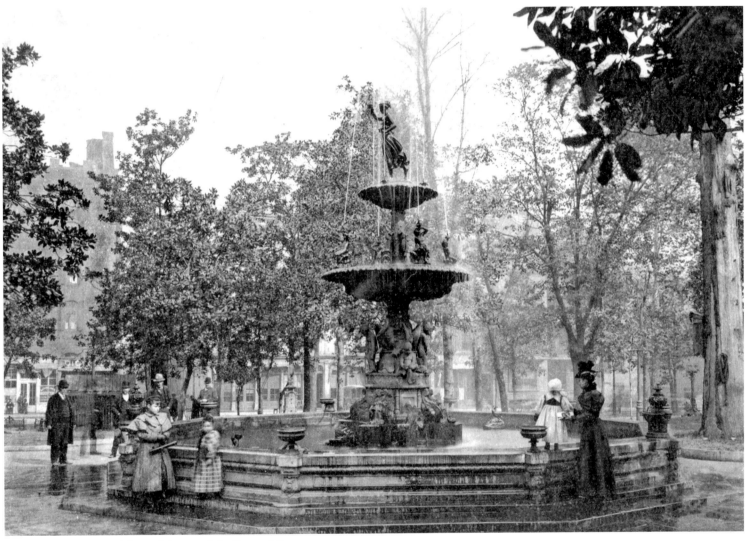

Court Square in 1895. The park is one of the four public squares originally designated in 1819. The fountain was erected in 1876 in honor of the nation's Centennial.

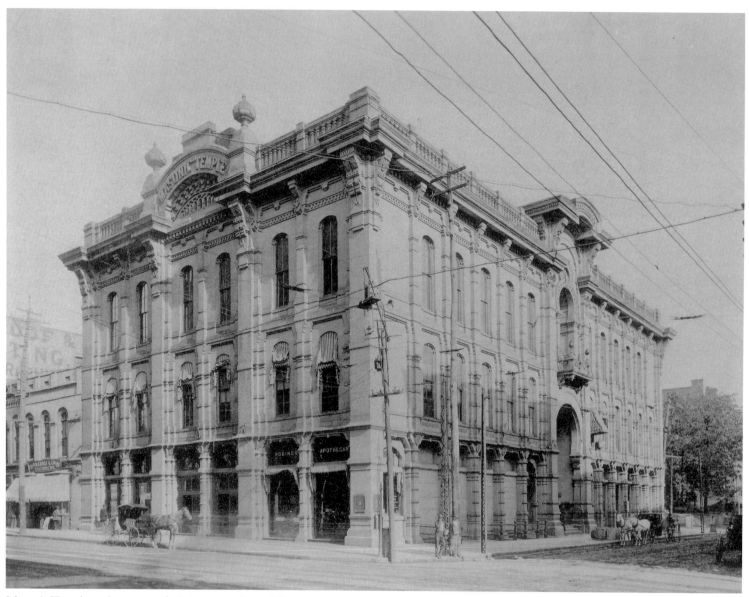

Masonic Temple at the corner of Madison and Second Street, 1895.

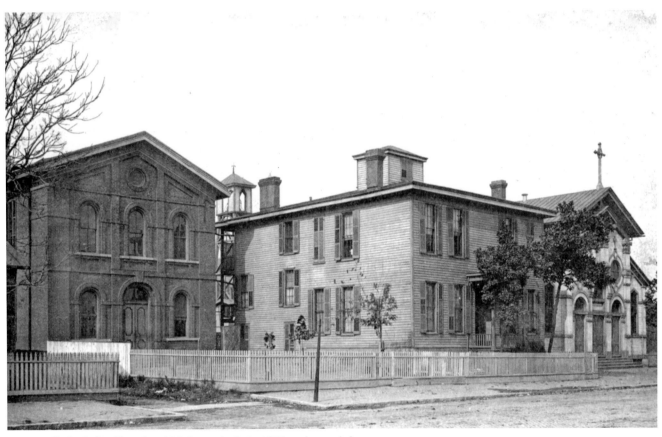

St. Brigid's Catholic Church, 1895. It was built in 1870 and served the largely Irish population of the Pinch District for many years.

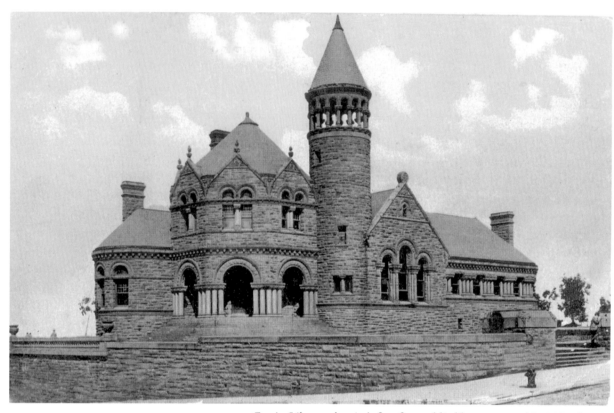

Cossitt Library, the city's first free public library, opened in 1893. It was financed by the heirs of dry goods magnate Frederick H. Cossitt. The original building featured a round tower and a triple-arched entry.

Workmen laying streetcar tracks on Main Street, 1891.

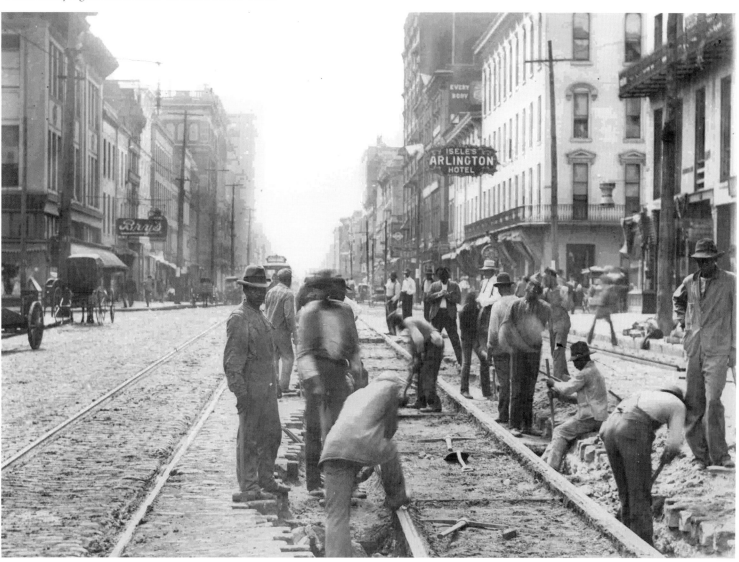

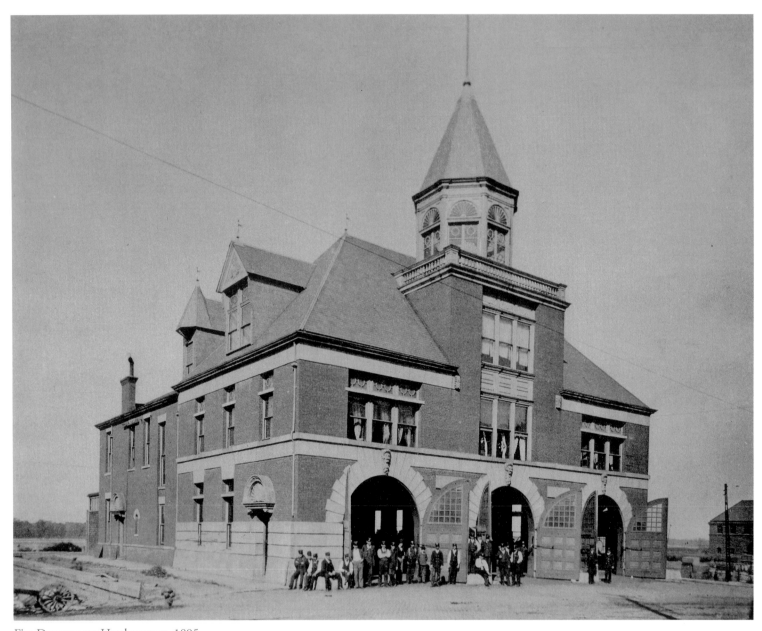

Fire Department Headquarters, 1895.

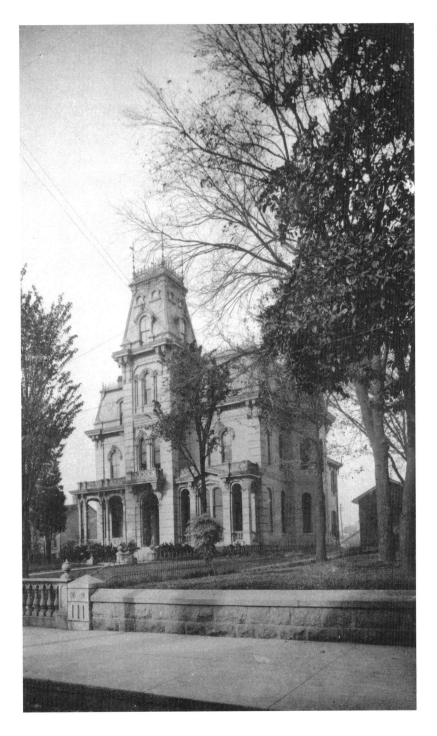

Cotton merchant Noland Fontaine's mansion at 340 Adams, 1900.

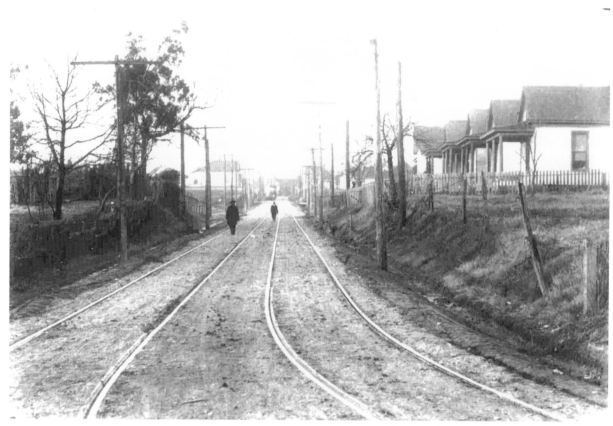

Scene on Latham Avenue at Trigg, looking
North to McLemore Avenue, circa 1895.

Memphis firefighters, circa 1890.

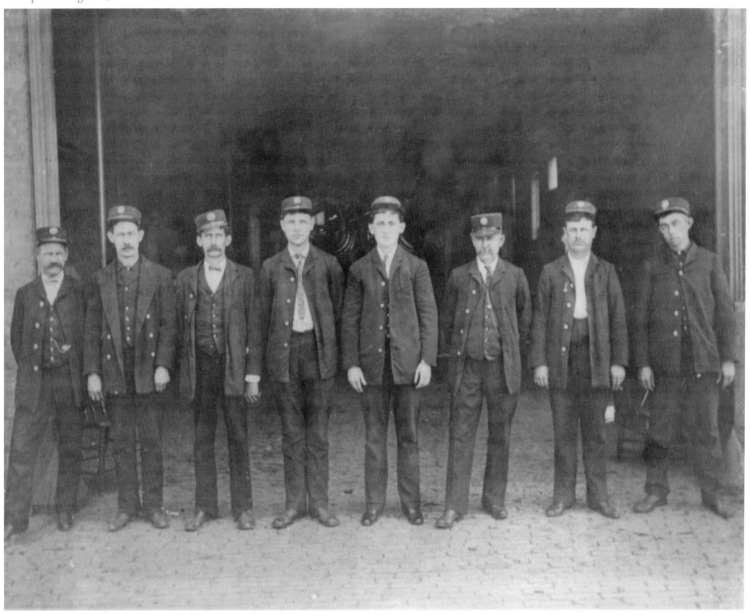

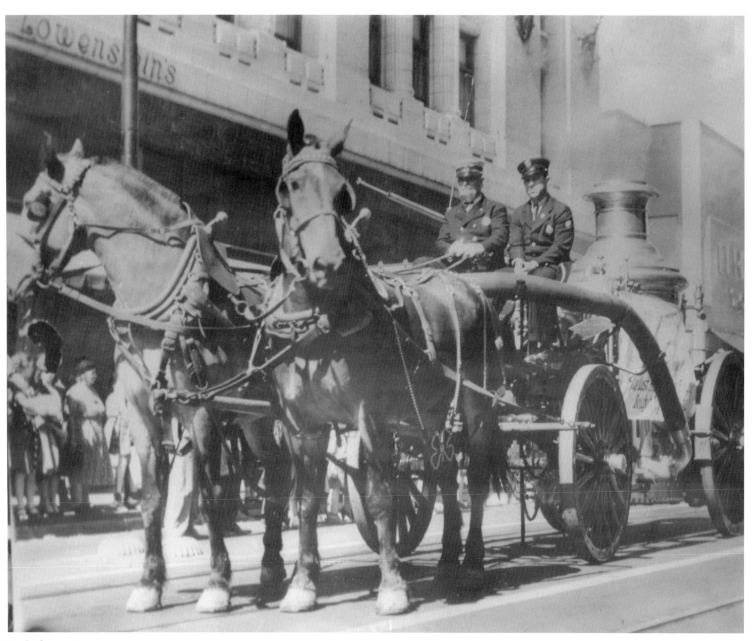

Early fire engine.

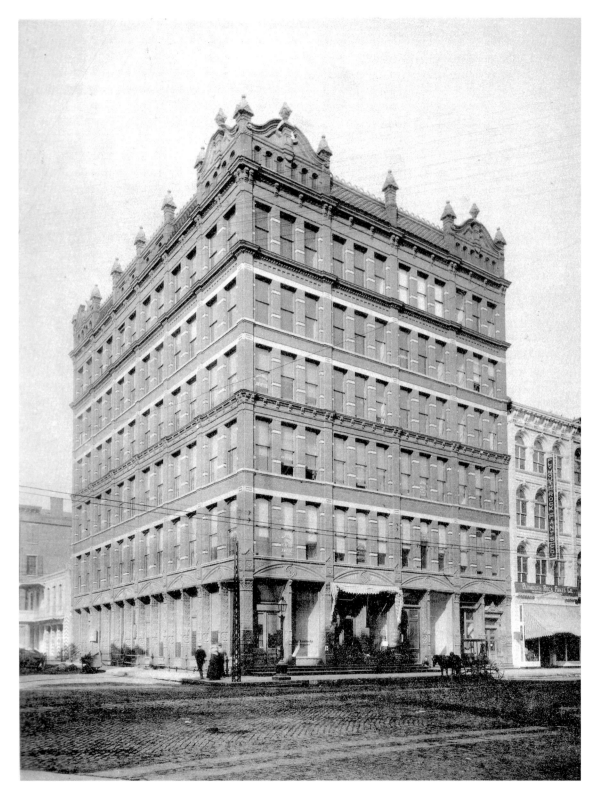

The Appeal Building, 1895. The building originally opened as the Collier Building in 1889, and in 1900 became the home of the Memphis newspaper The Appeal.

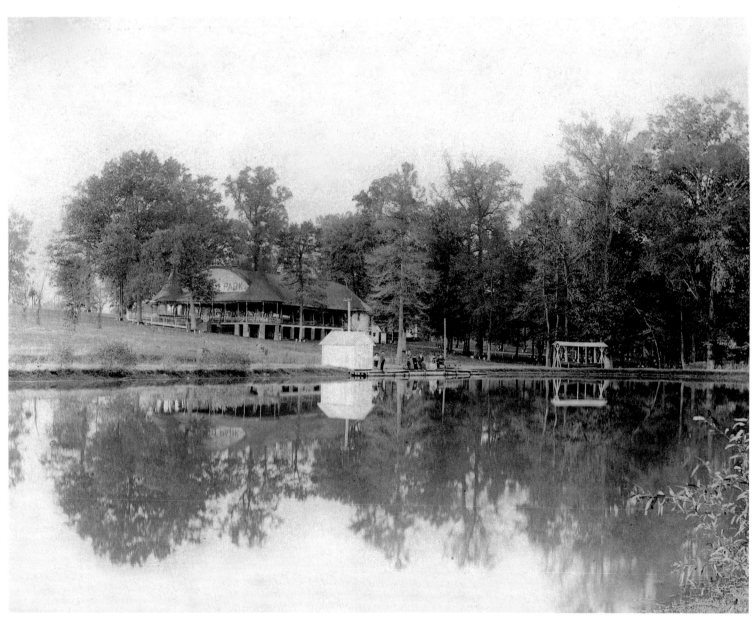

East End Park, 1895. The park lasted from 1889 until 1913 and was a favorite gathering place of the local German community.

Tennessee Brewing Company at 477 Tennessee Street, 1895.

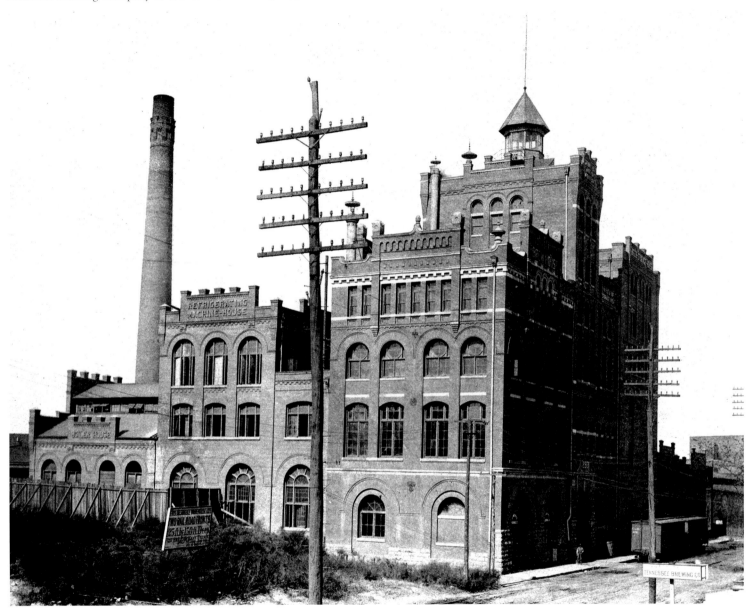

Residence of cotton merchant Napoleon Hill, 1900.

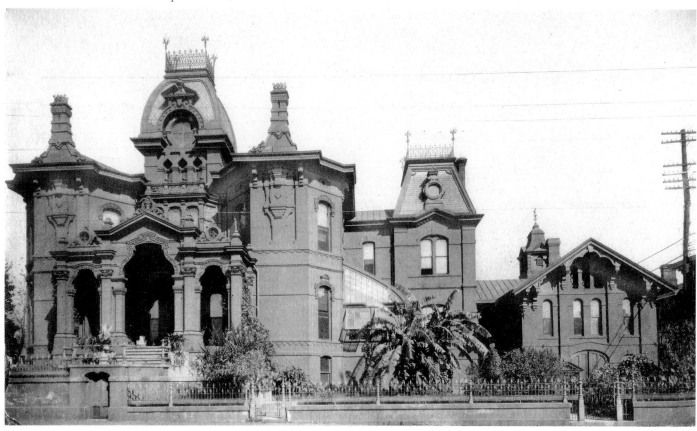

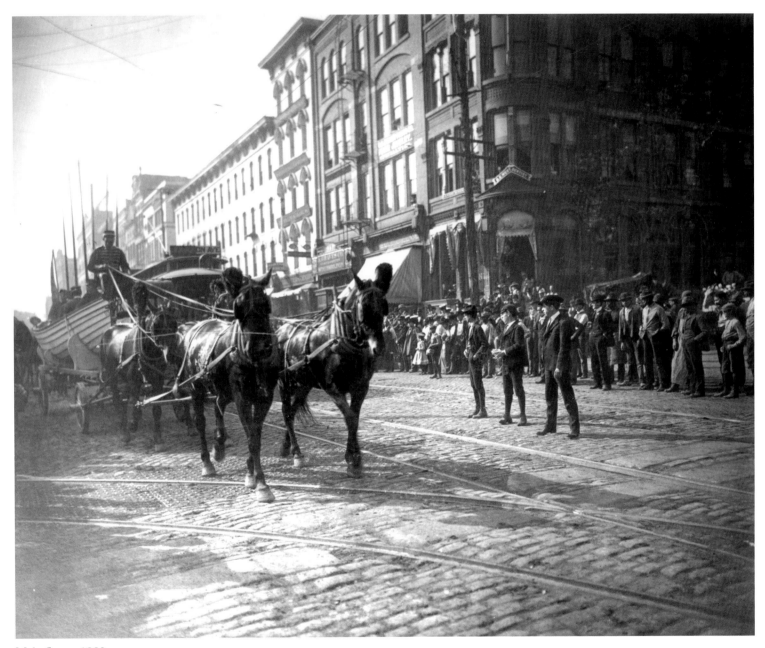

Main Street, 1880s.

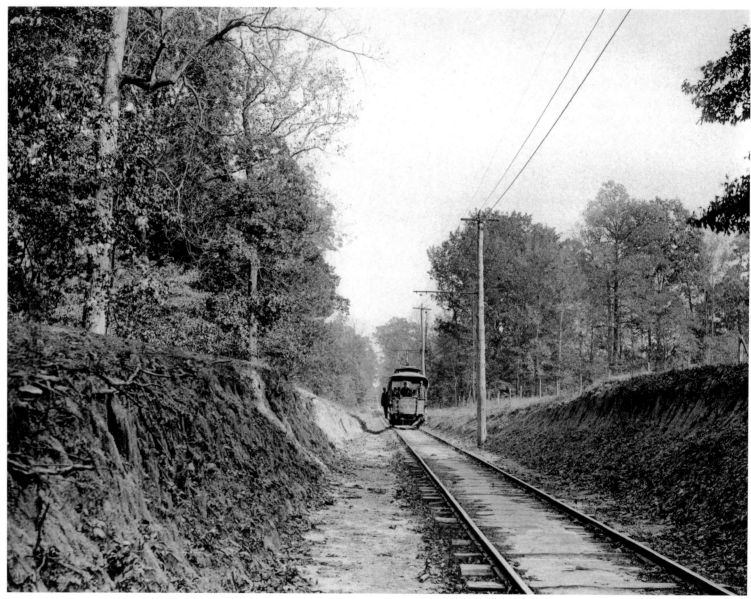

Raleigh Springs Car Line, 1895. A railroad was built to this popular resort in 1871 then replaced by an electric street car line in 1891.

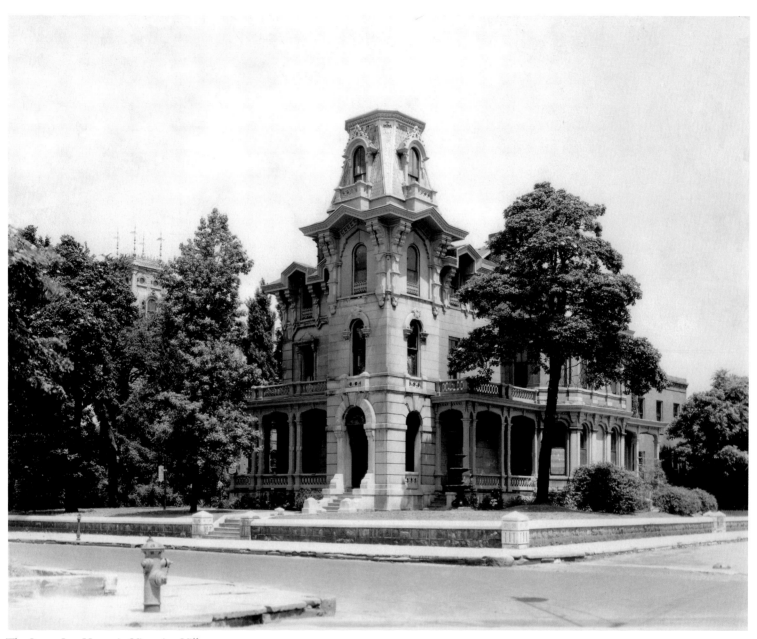

The James Lee House in Victorian Village.

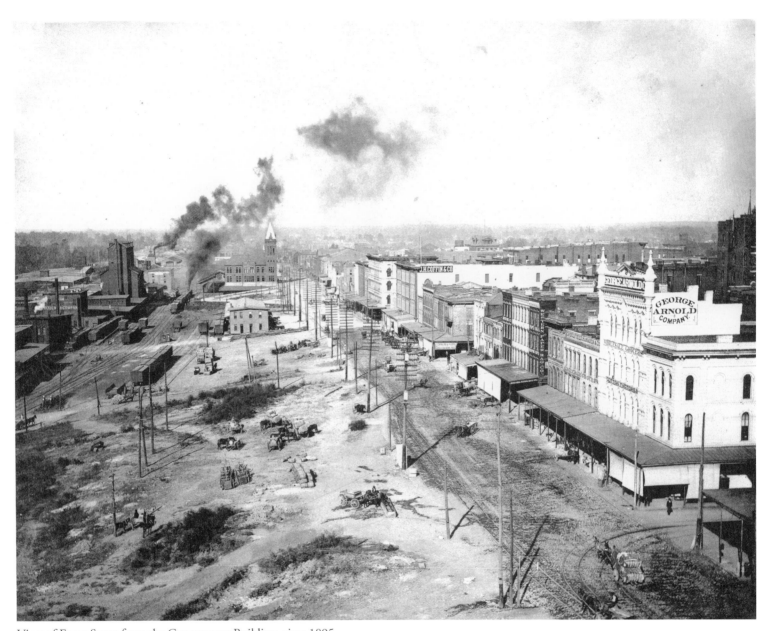

View of Front Street from the Government Building, circa 1895.

Orgill Brothers on Front Street.

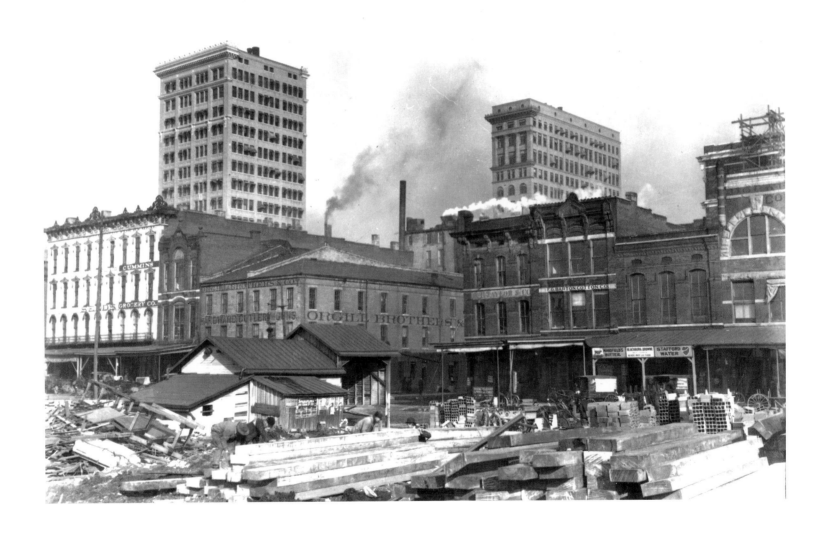

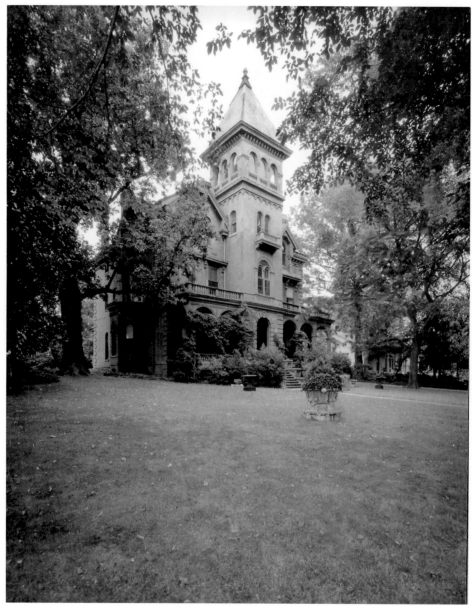

The Mallory-Neely House at 652 Adams Avenue in Victorian Village. The house was built in the 1850s and additions were made in the 1870s and 1880s.

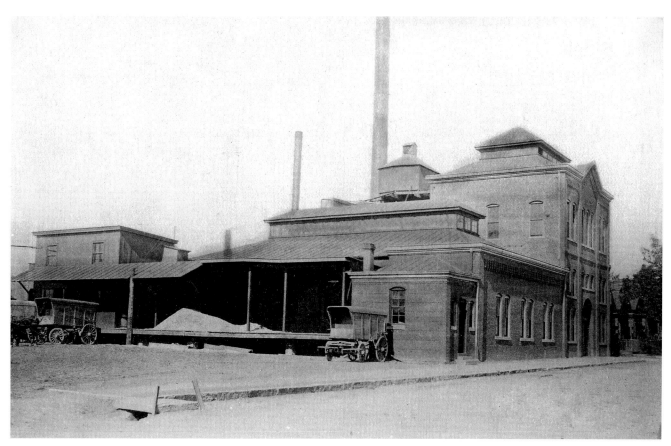

Bohlen-Huse Ice Company. John Bohlen began operating the City Ice House before 1855. Originally, ice was cut from frozen northern lakes and stored in the company's underground ice houses. Later, artificial means were used to produce ice from local artesian water.

The Magevney House at 198 Adams, built circa 1833. Irish-born Eugene Magevney was a teacher and real estate entrepreneur. His home was the site of the first Catholic Mass, Marriage, and Baptism in Memphis.

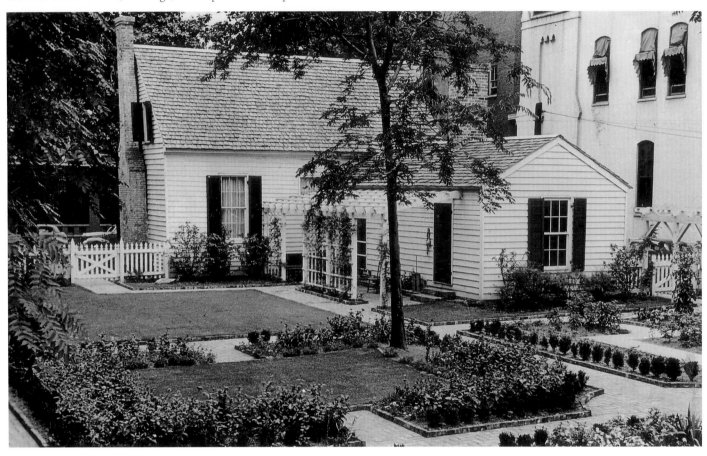

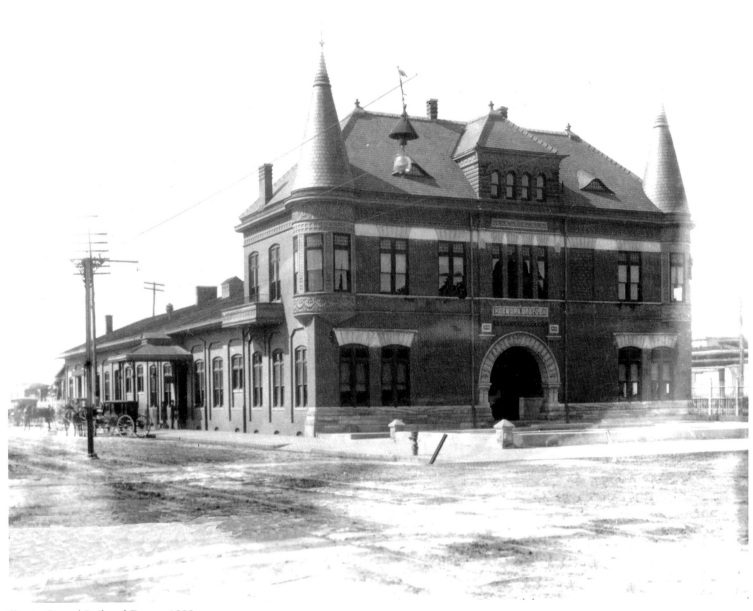

Illinois Central Railroad Depot, 1899.

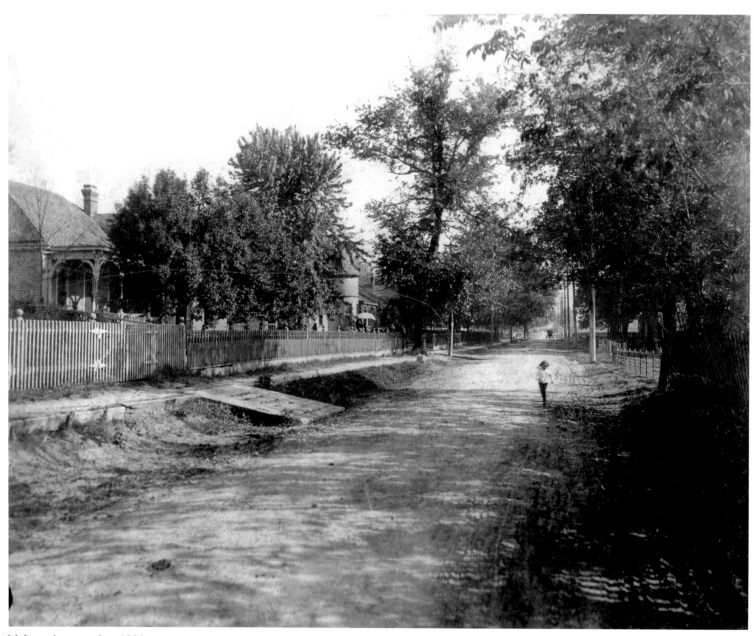

McLean Avenue, circa 1890.

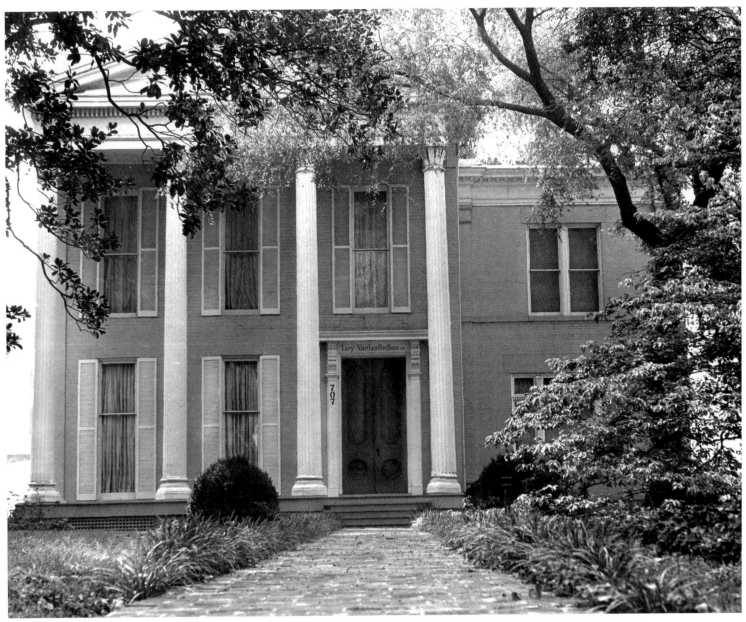

The Pillow-McIntyre House at 707 Adams in Victorian Village. Built in the 1850s, the home once belonged to Civil War General Gideon Pillow. The Free Art School of the Memphis Art Association held classes in the home from the 1940s to the 1960s.

Union Avenue in 1895.

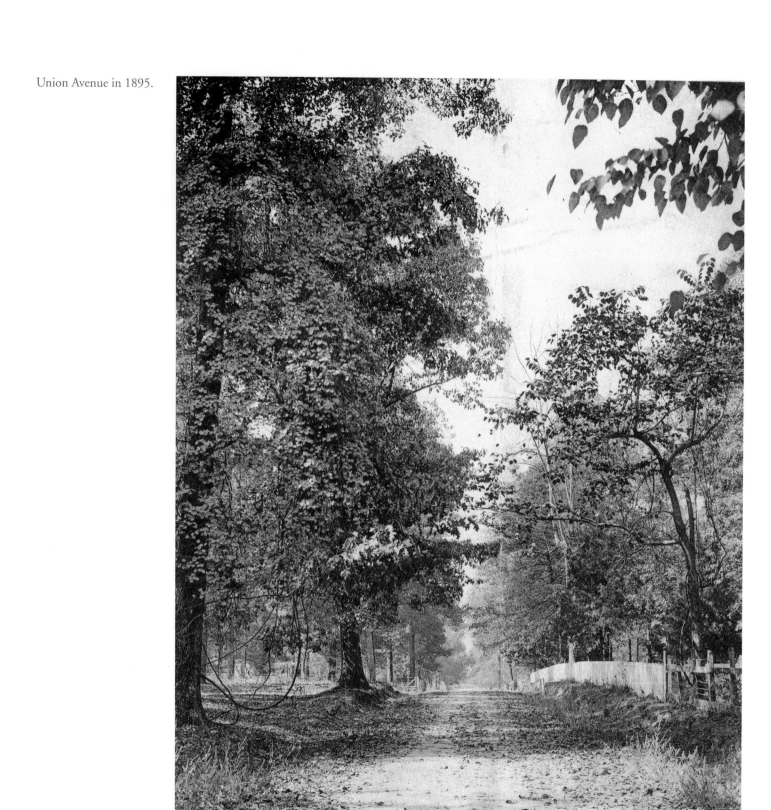

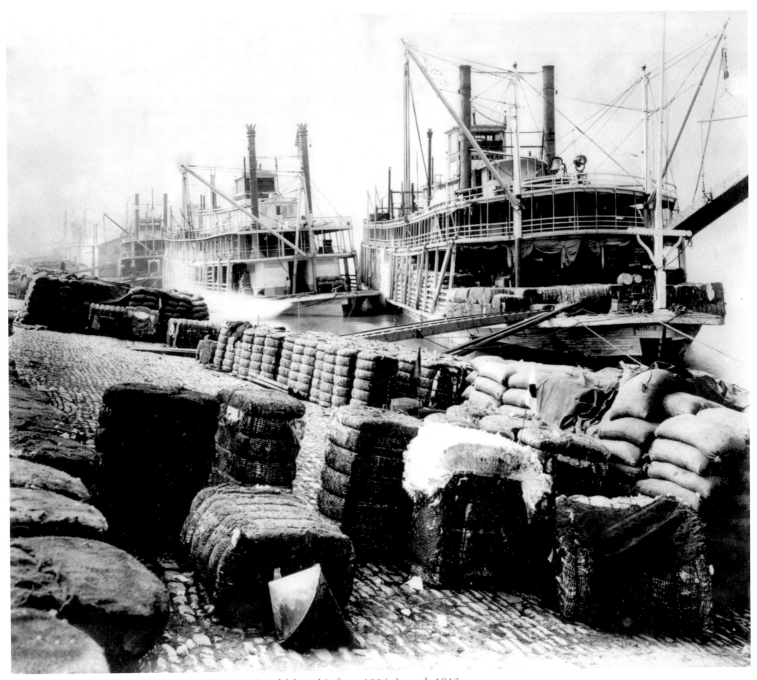

The *Peters Lee* shipped freight between Cincinnati and Memphis from 1904 through 1913.

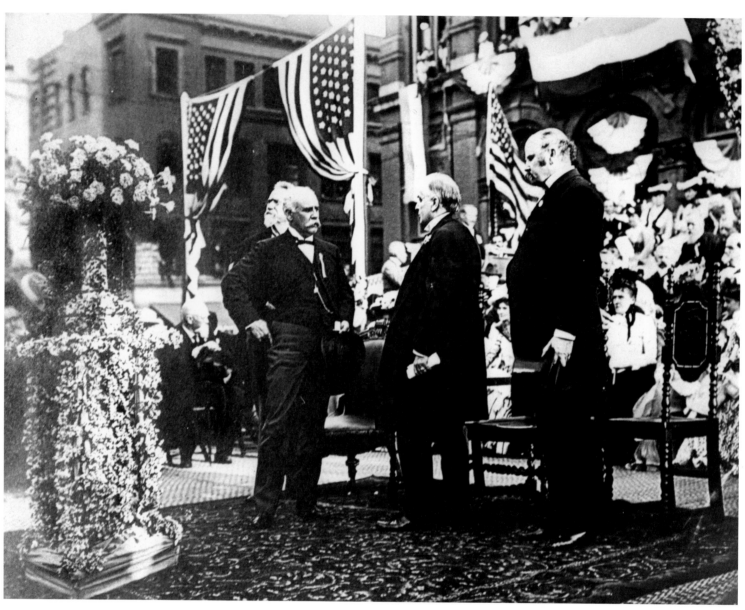

President William McKinley being greeted by Memphis Mayor J.J. Williams
in Court Square on May 1, 1901.

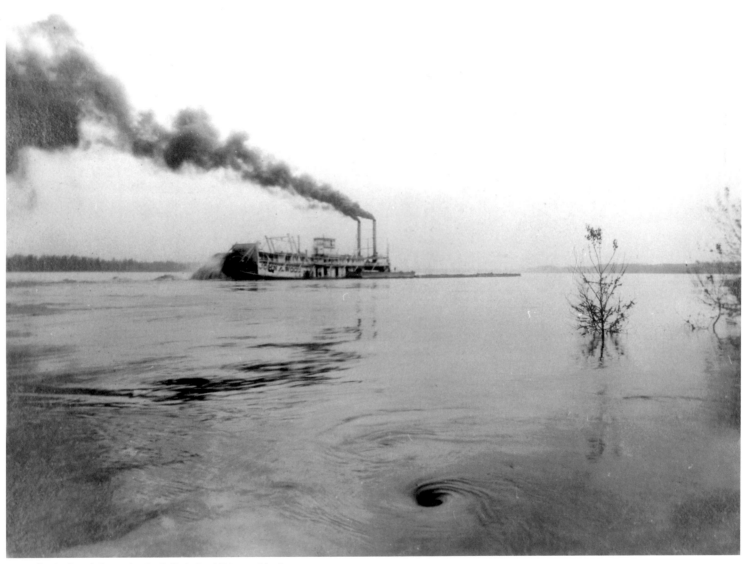

A small whirlpool forms in the Mississippi River with the steamer
John A. Wood in the background.

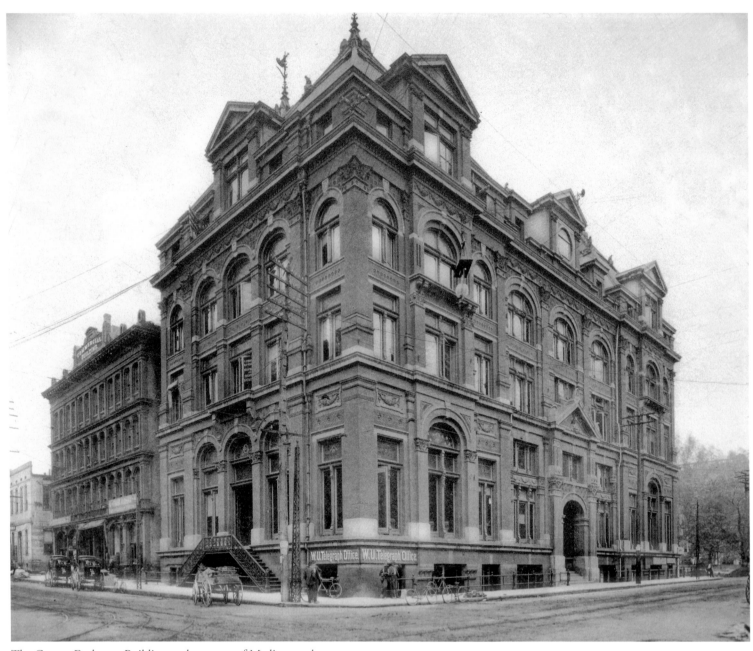

The Cotton Exchange Building at the corner of Madison and
Second, 1900.

The steamer *Katie Robbins,* circa 1890.

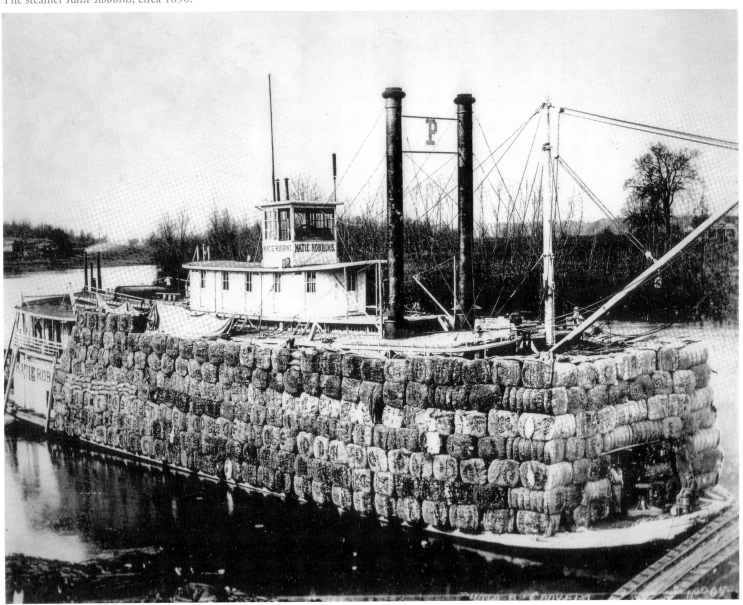

At the turn of the century, Memphis prided itself as the "hardwood capitol of the world."

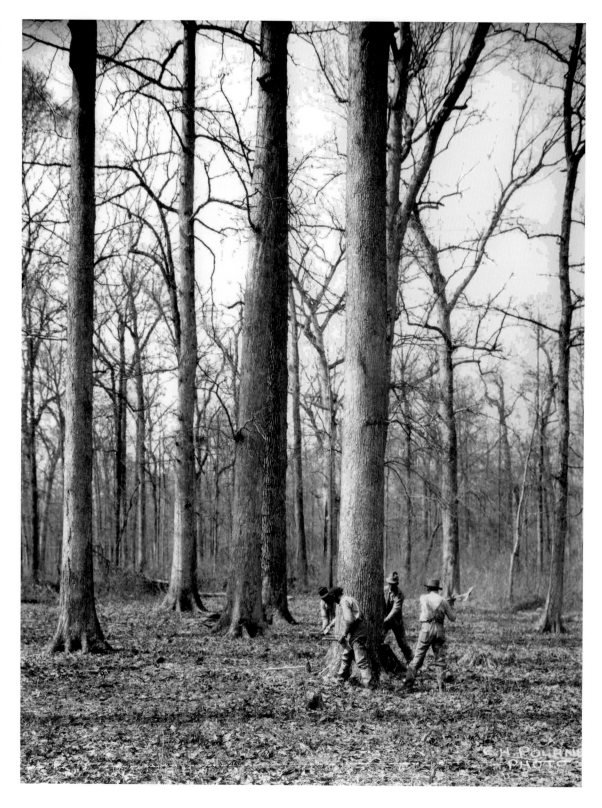

MEMPHIS AT THE TURN OF THE CENTURY

1900-1919

Memphis proudly claimed to have the world's largest cotton and lumber markets, the country's largest inland river port and the largest railroad center in the South at the turn of the century. Reform-minded citizens' organizations fought the new city government's impulse to fall back on cronyism and inefficiency. There were some improvements, but in general, local leadership generally lacked decisiveness. This pattern of inaction ended with the ascension of Edward Hull Crump, who dominated Memphis politics through the 1950s.

Flooding was an ever-worsening problem in the early twentieth century especially in the Mid-South. Continuing deforestation and the resulting erosion made these seasonal events life-threatening disasters. The worst floods hit in 1912, 1913, 1927 and 1937. Not only did the waters find their way into parts of Memphis, but the city had to accommodate thousands of refugees from surrounding areas.

Despite facing bigotry and inequity, African Americans managed to make significant economic and political advances beginning in the 1900s. Robert R. Church, Jr. formed the Lincoln League in 1916 to encourage voter registration and in 1917 he organized the local chapter of the NAACP. Uniting in these organizations was beneficial to the African American community as Church and others were able to take advantage of Crump's need for votes to gain concessions from the political machine.

Improvements and innovations characterized this period as well. The opening of the Overton Park Zoo in 1906 and the founding of the park system in 1911 was followed by a movement to build safe public playgrounds in 1915. There were numerous advancements in education including the merging of The University of Tennessee Medical School with Memphis Hospital Medical College. Central High School was built in 1911 and The West Tennessee State Normal School, forerunner of the University of Memphis, opened the following year.

Beale Street had been a melting pot of Italians, Germans, Irish, Jews and African Americans, among others, but by the 1900s, it was known as a center of African American culture in the South. The street was home to numerous Black-owned businesses and offices, including physicians, dentists, lawyers, undertakers, teachers, photographers, barbers and insurance companies. Yet it was music, most notably the Blues, which made Beale Street famous.

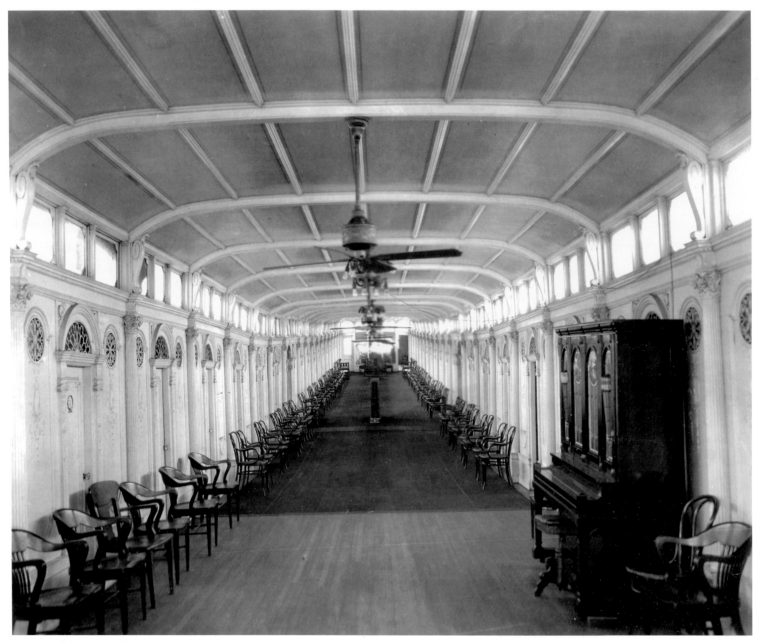

Interior of the *Kate Adams III*, circa 1903.

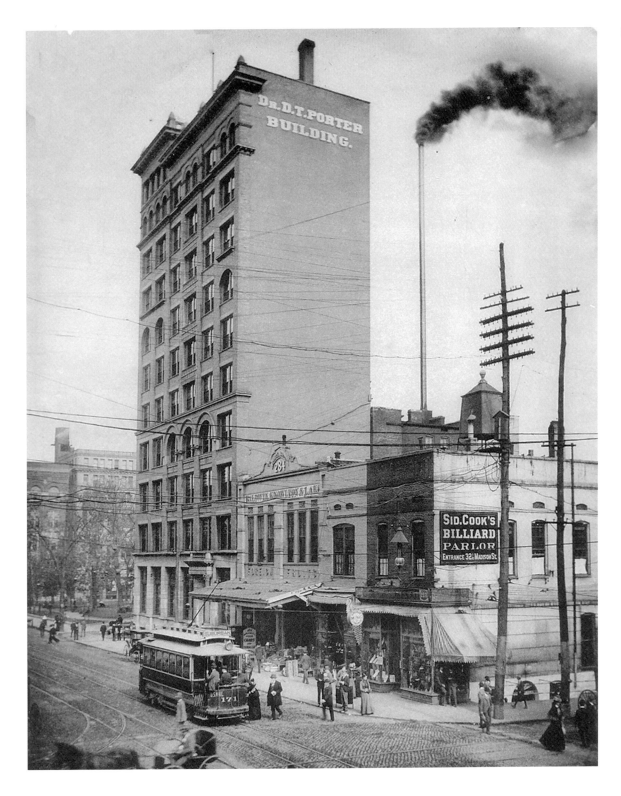

Scene on Main Street, 1900.

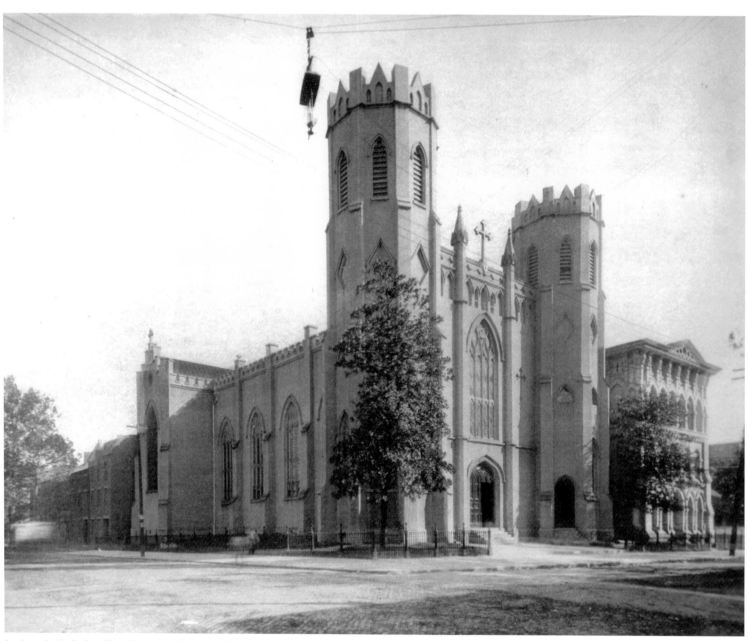

St. Peter's Catholic Church, 1900. Completed in 1855, this was the
first Catholic Church in Memphis.

Interior of St. Peter's
Catholic Church.

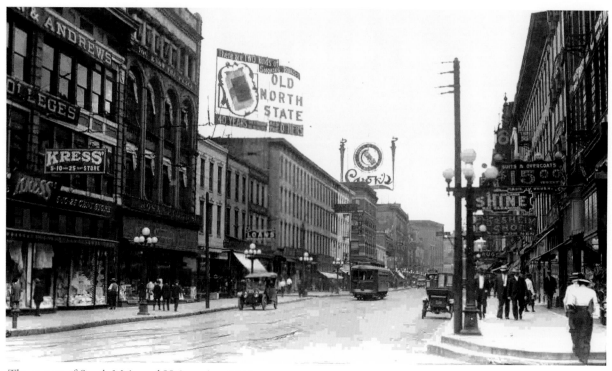

The corner of South Main and Union, circa 1910.

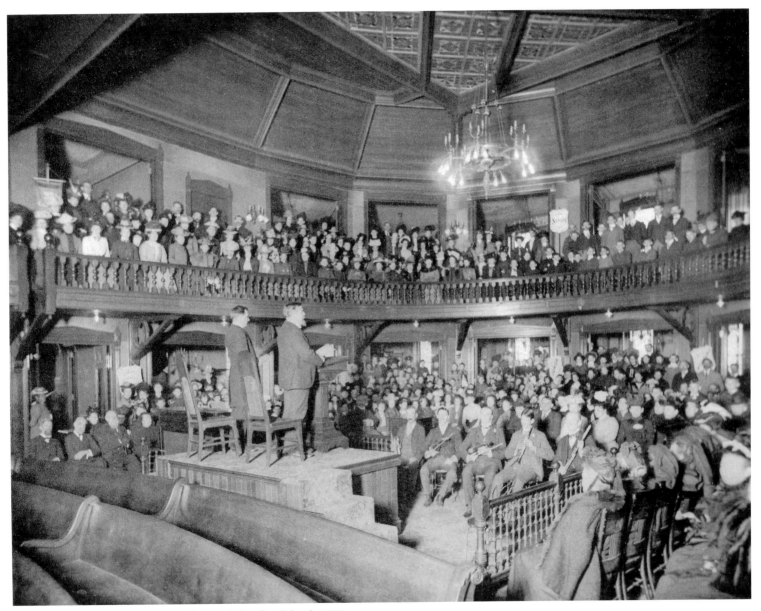

Interior of First Methodist Episcopal Church Sunday School, 1900.

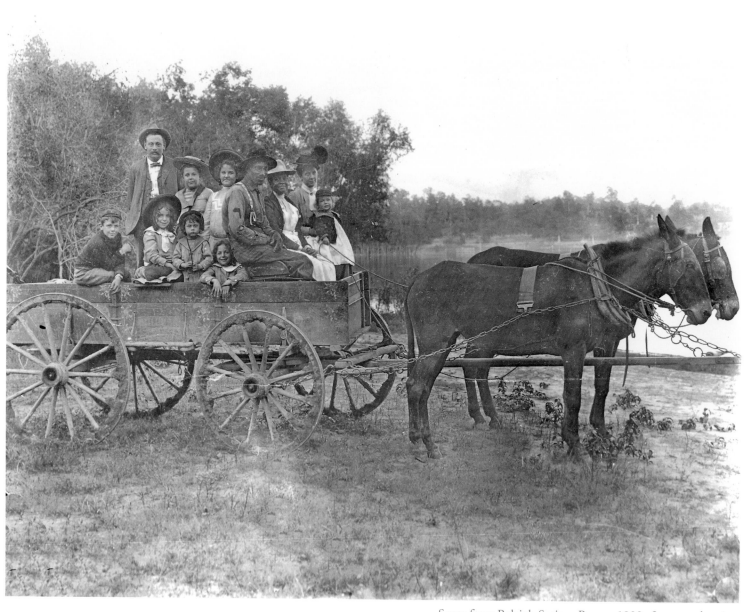

Scene from Raleigh Springs Resort, 1902. Its natural spring water made it a popular destination for Memphians.

Raleigh Springs Resort, 1900.

Irishman Paddy Meagher, owner of the Bell Tavern, arrived at the Chickasaw Bluff around 1813. His many guests included Andrew Jackson, Isaac Shelby and David Crockett.

A mule-drawn Coca-Cola wagon driven by Landan Smith. Mack's Saloon,
which was operated by Charles McClelland, appears in the background.

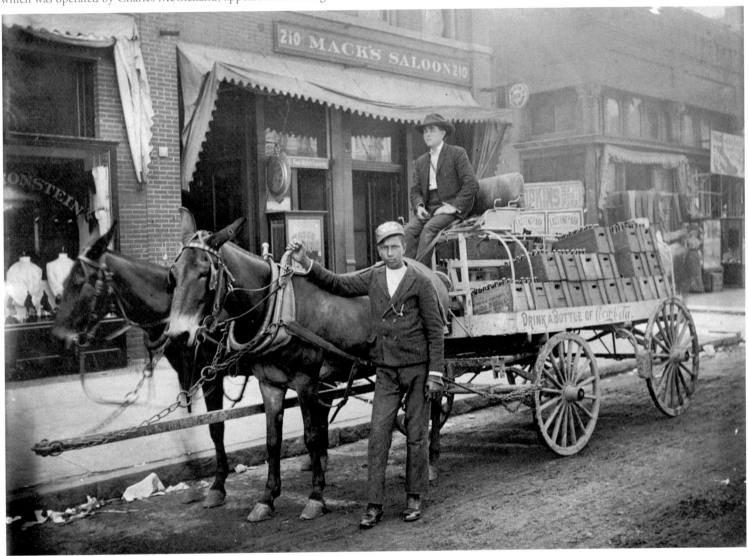

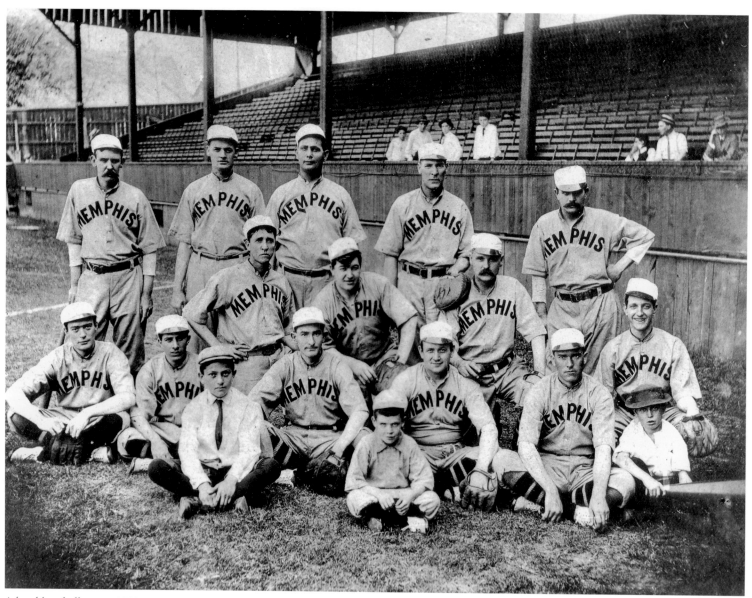

A local baseball team, 1900s.

Horseracing at Montgomery Park, circa 1900.

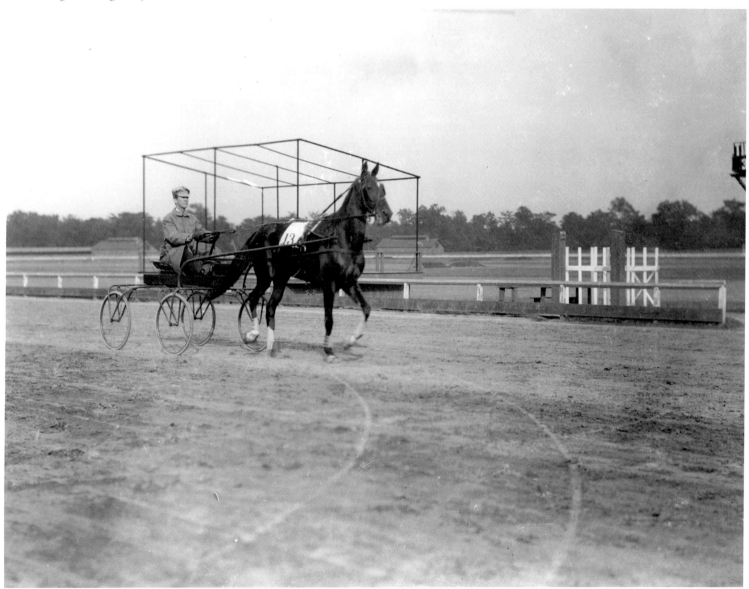

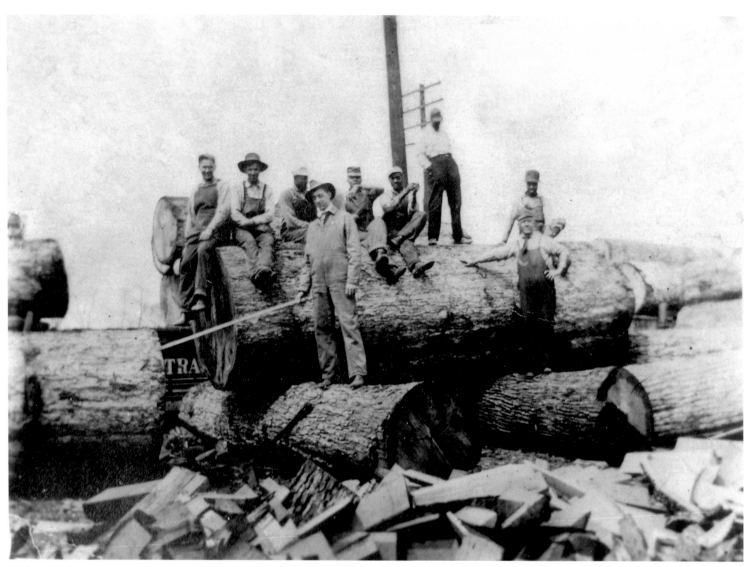

Nickey Brothers Lumber Company, 1908. A.B. Nickey's business, which he opened in 1866, lasted through the 1980s. One of the largest fires in Memphis history broke out at the company's Summer Avenue facility in 1964 and destroyed a number of warehouses.

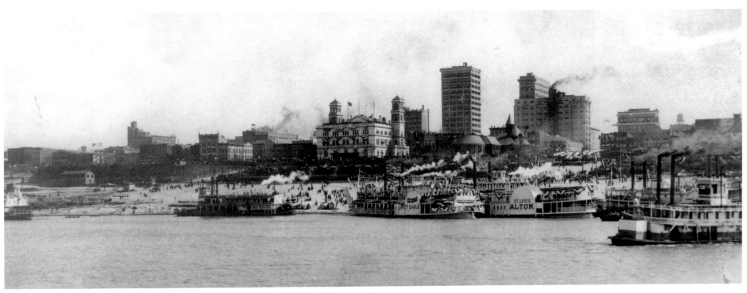

The steamboats *Grey Eagle* and *Alton* docked at the waterfront at Memphis, 1909.

Photo on following page: T. H. Hayes and Sons Funeral Home employees next to
Beale Street First Baptist Church. Hayes came to Memphis in 1879 and opened
his business at the suggestion of Robert R. Church.

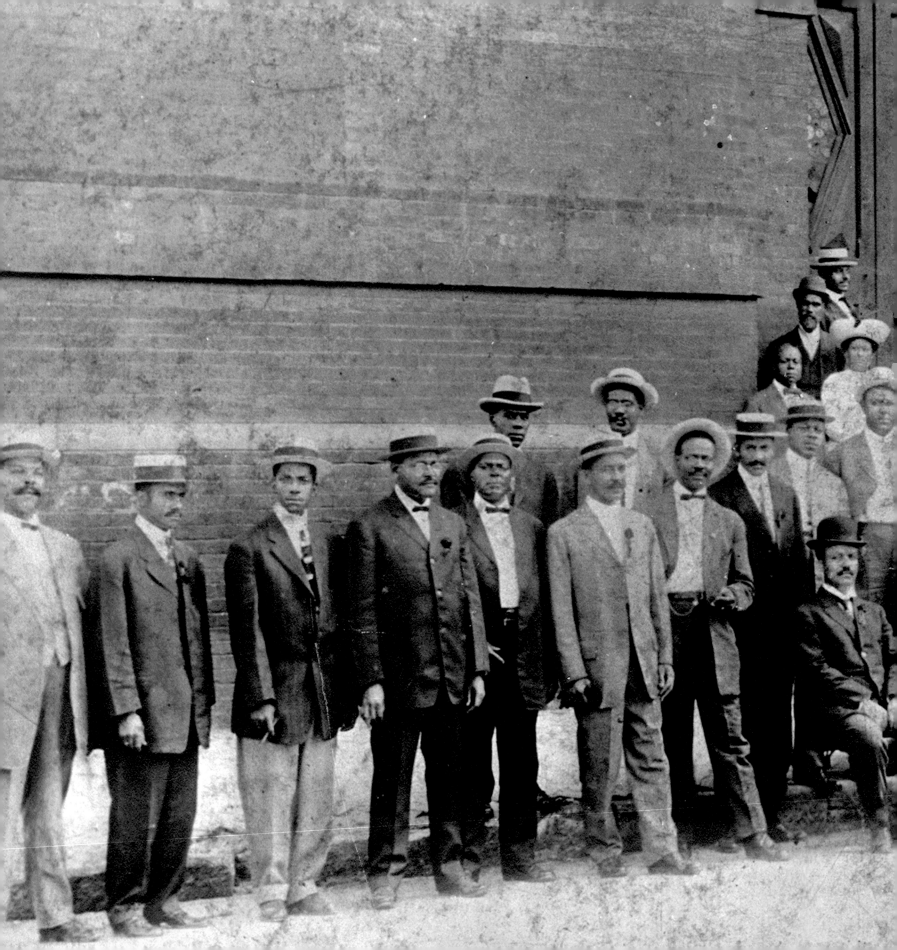

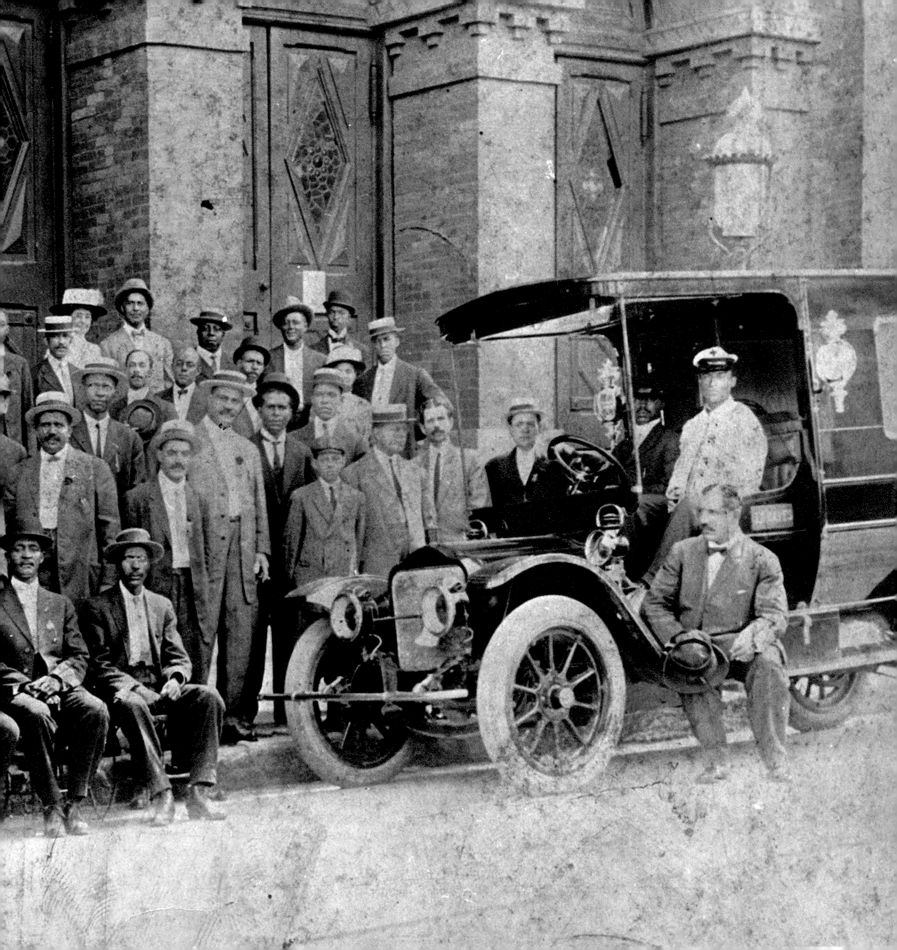

Scene on Main Street near Court Square.

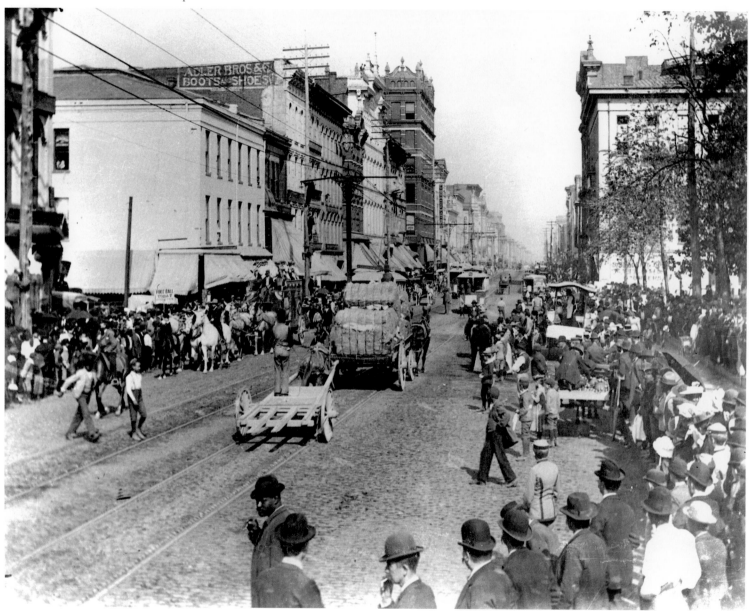

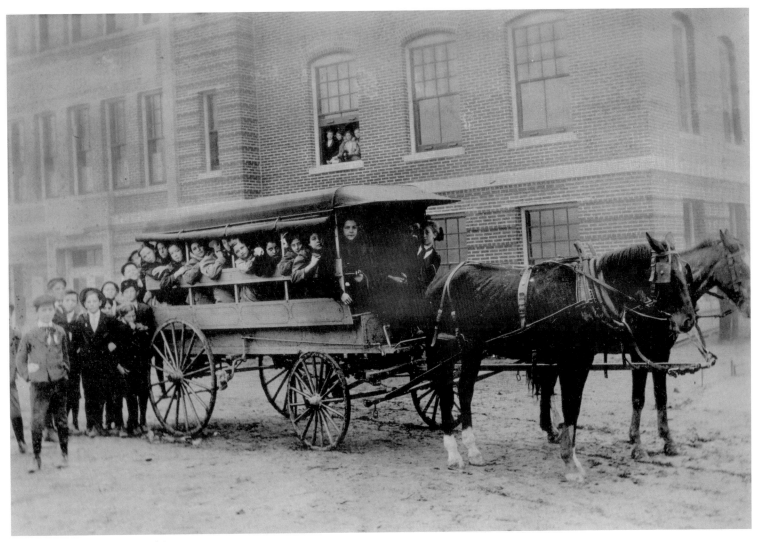

The first schoolbus in Memphis.

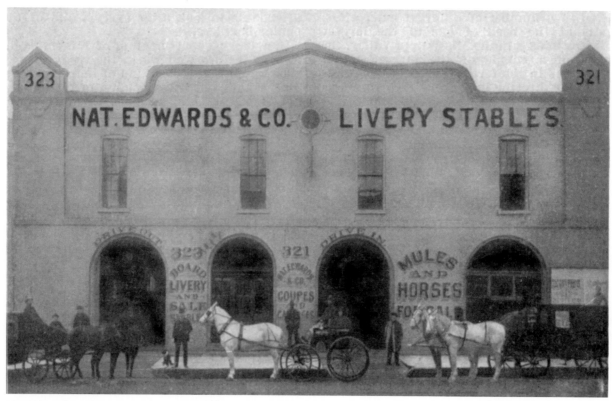

Nat Edwards and Company Livery Stables.

Grover Cleveland Sherrod, who went on to serve as the U.S. District Attorney General for the 13th District, in his grocery store, circa 1910.

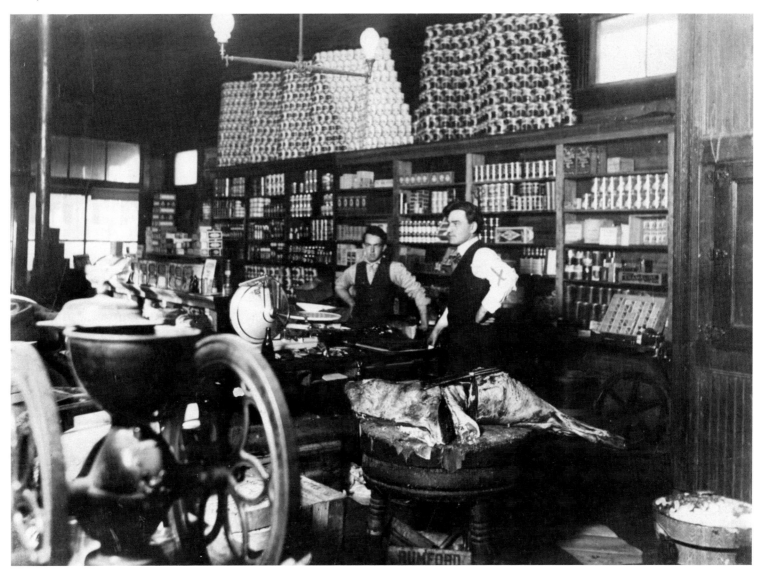

Business Men's Club election, 1911. The organization was founded in 1900 and moved into the building pictured at 81 Monroe in 1907. Beginning in 1913, the building was the headquarters for the Memphis Chamber of Commerce.

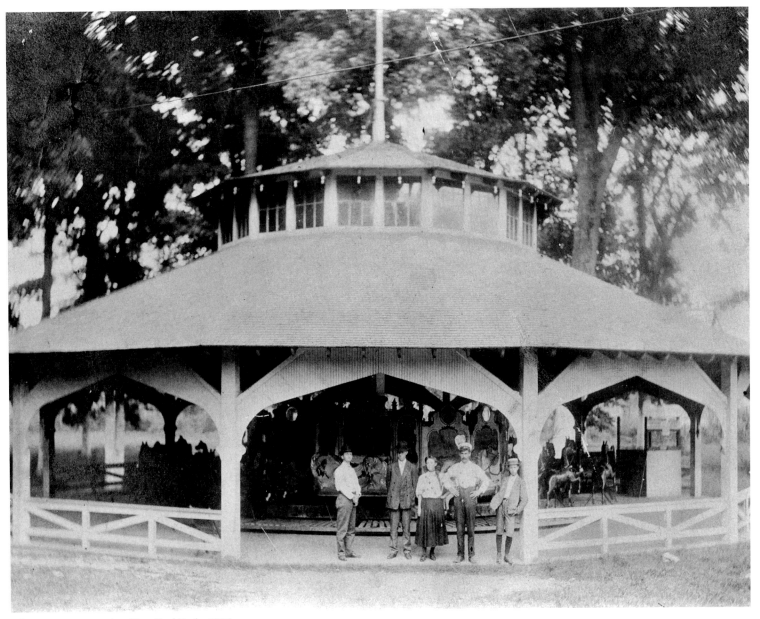

The merry-go-round at East End Park, 1911.

Main Street, 1912.

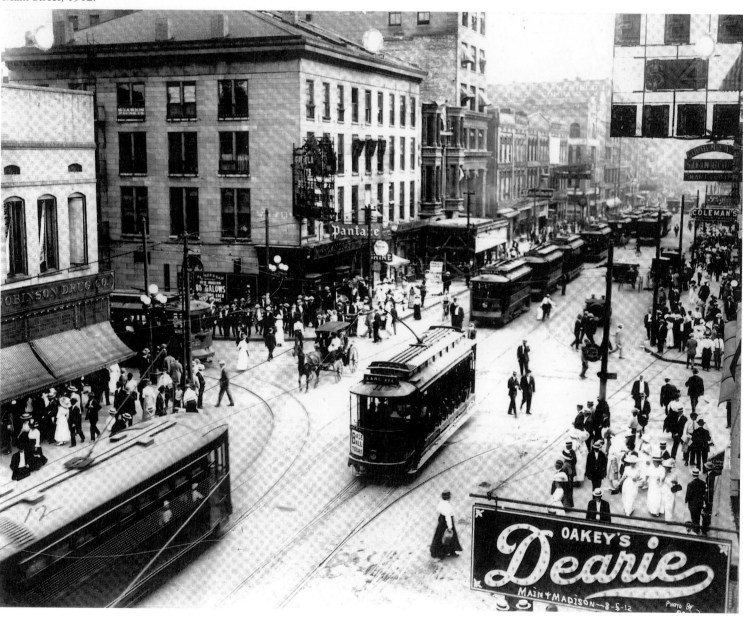

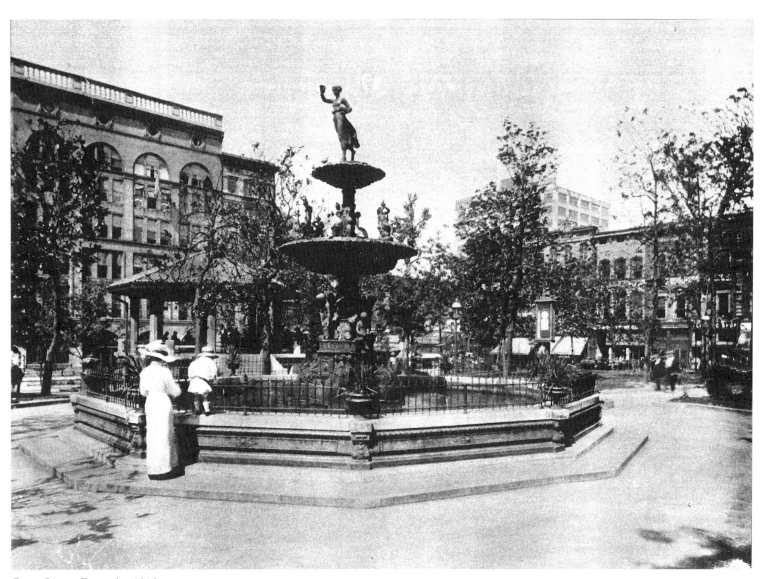

Court Square Fountain, 1912.

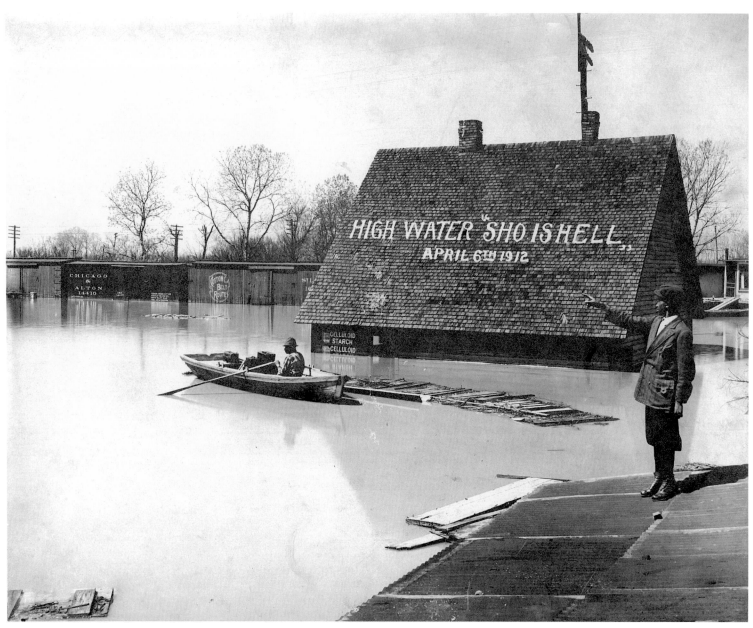

Scene from the 1912 Mississippi River flood. Memphis was relatively safe from high water, but some low-lying areas in the city became susceptible to rising back water as flood levels worsened at the beginning of the 20th century.

Memphis was a haven for Mid-South flood refugees. Facilities such as "Camp Crump," pictured here in 1912, were set up in the city to house refugees.

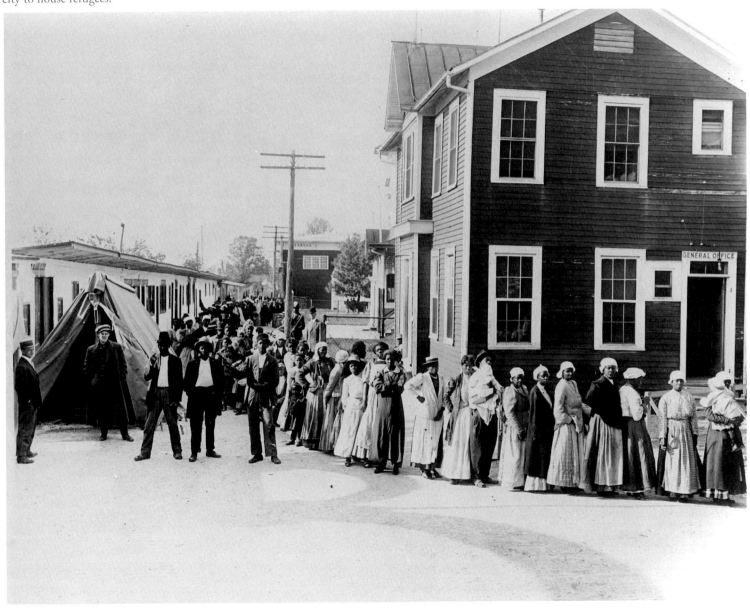

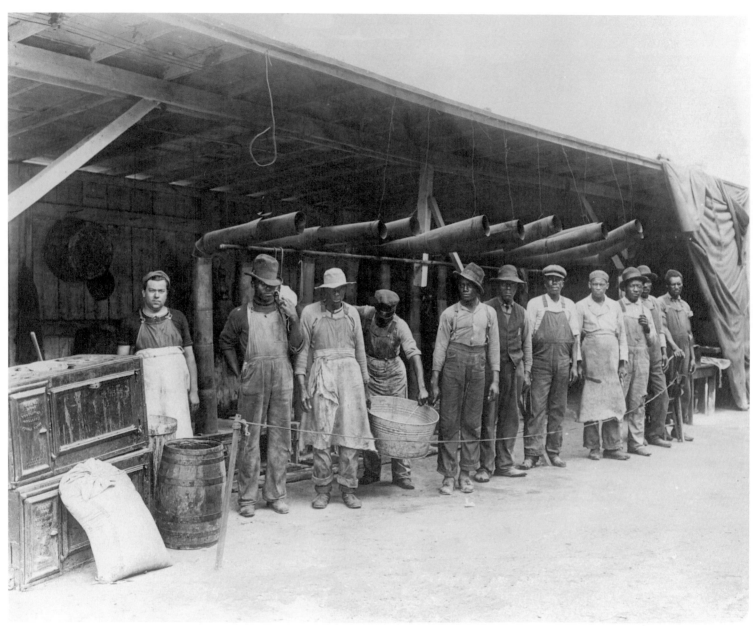

Camp Crump Refugee Camp, 1912. Refugees were often required to
perform manual labor in return for assistance.

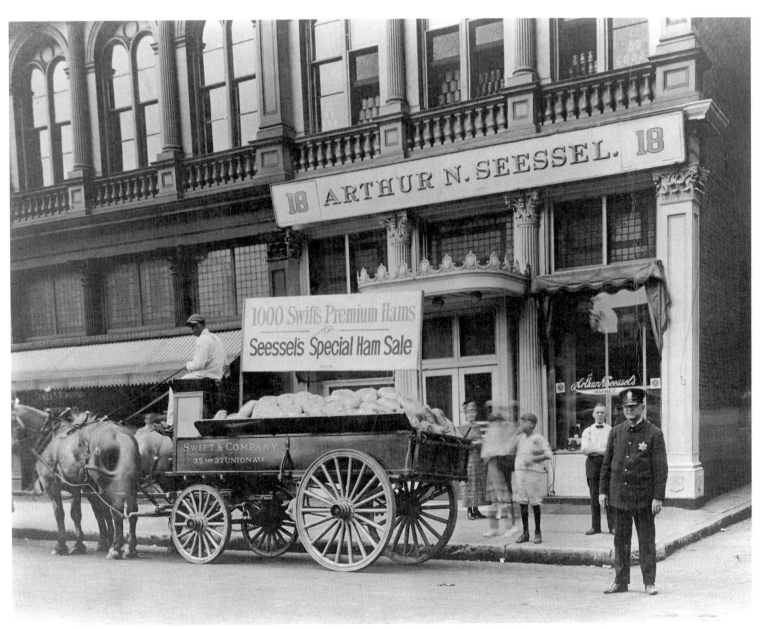

German-born Henry Seessel arrived in Memphis in 1857 and began a butcher business. In 1917, his grandson Arthur opened a full-line grocery, pictured here at 18 North Second. The Seessel family owned a chain of grocery stores which lasted until 2002.

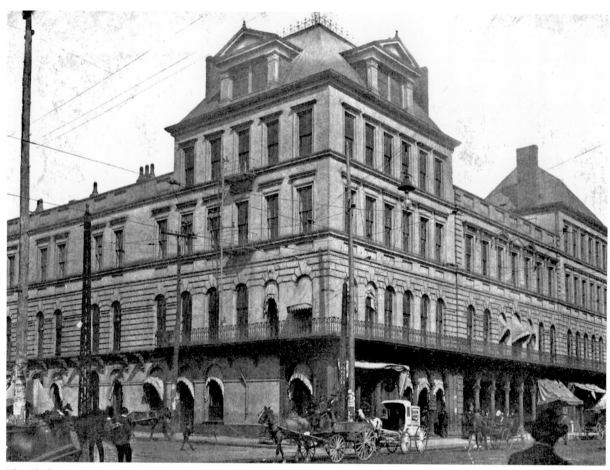

The Shelby County Court House, circa 1890. The
Overton Hotel at Main and Poplar Avenue was completed
in December 1860. It was sold to the city in 1874 and
used as the Shelby County Courthouse until 1909.

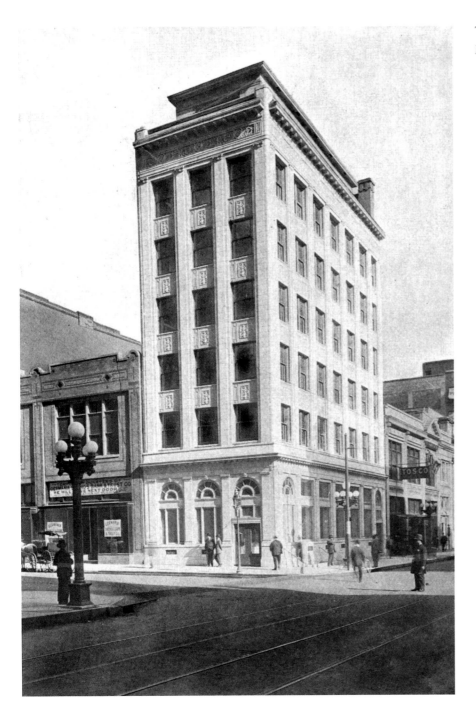

The Germania Bank Building at Second and Madison Avenue, 1913.

Beale Street and Hernando, circa 1915.

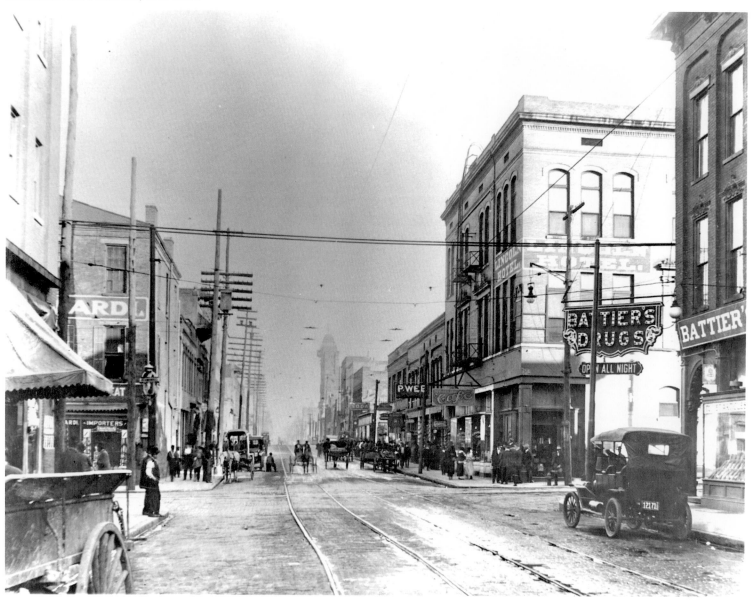

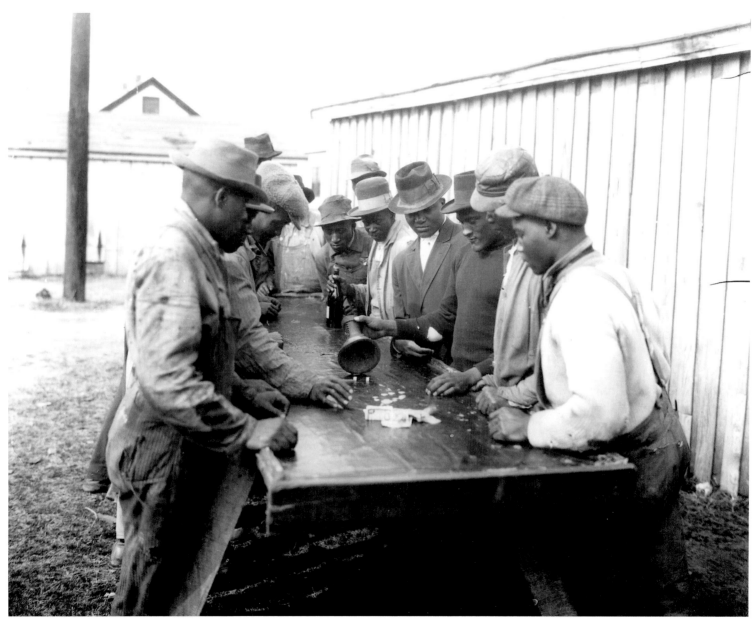

Mayor David "Pappy" Hadden supposedly created the Hadden's Horn
as a way to ensure people could not cheat when throwing dice.

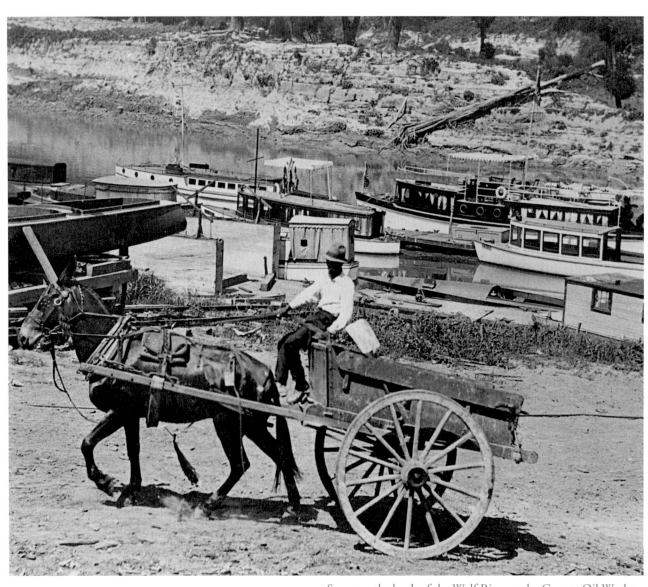

Scene on the bank of the Wolf River at the Gayoso Oil Works.

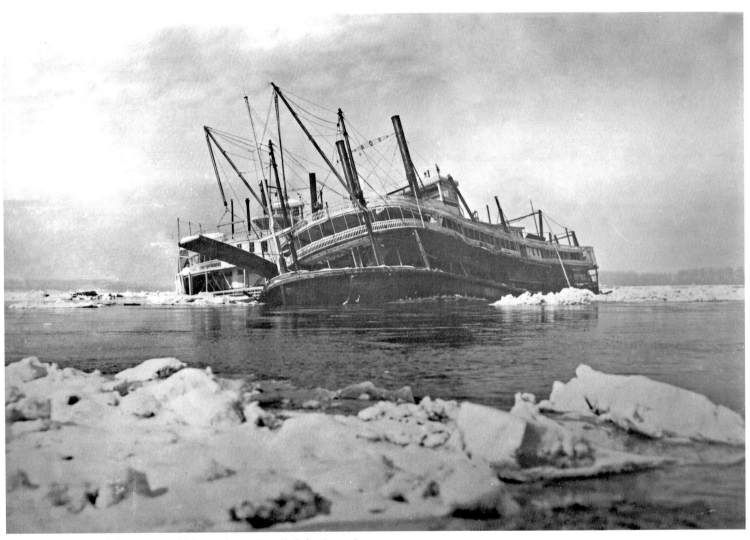

The *Georgia Lee* and the *Desoto*, which was formerly called the *James Lee*, were
two of the vessels destroyed when the Mississippi River froze in January 1918.

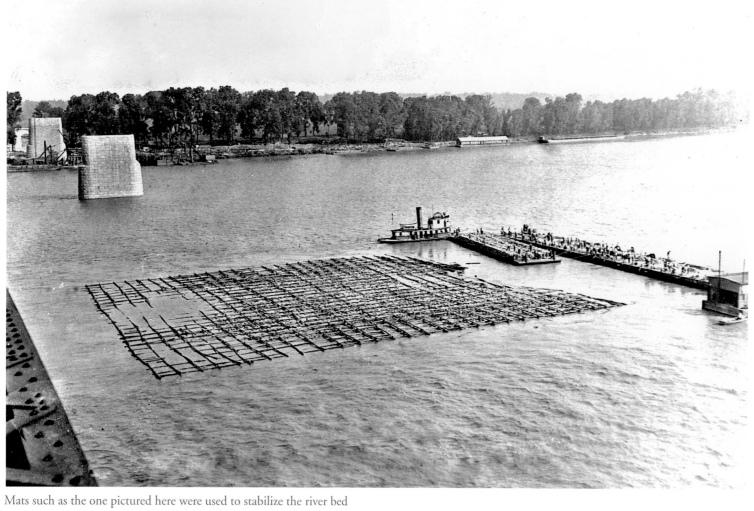

Mats such as the one pictured here were used to stabilize the river bed for the construction of the Harahan Bridge in 1914.

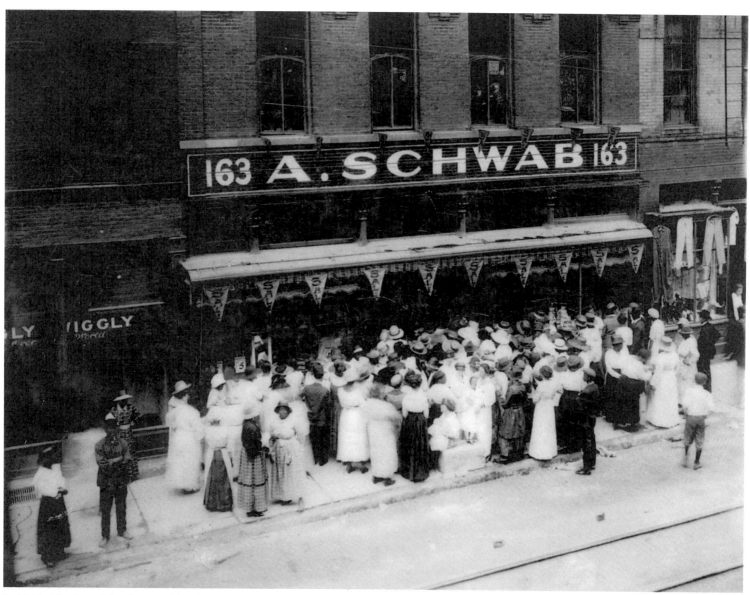

In 1912, Abraham Schwab moved his dry goods business from 149 to 163 Beale Street to accommodate his growing business. Schwab's has been in business on Beale since 1876.

The Cordova Hotel at the corner of Third and Madison.

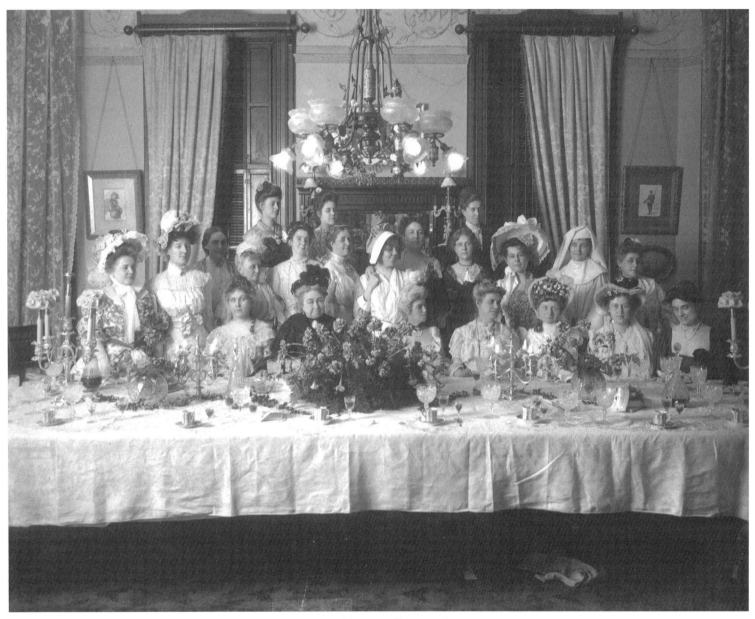

Members of the Memphis Woman's Club, 1904. The Woman's Building at Jefferson and
Third opened in 1898 in the building occupied by the Post Office during the Civil War.
It was the scene of Memphis society's most exclusive balls and the home of studios where
Memphians learned music and the latest dance steps.

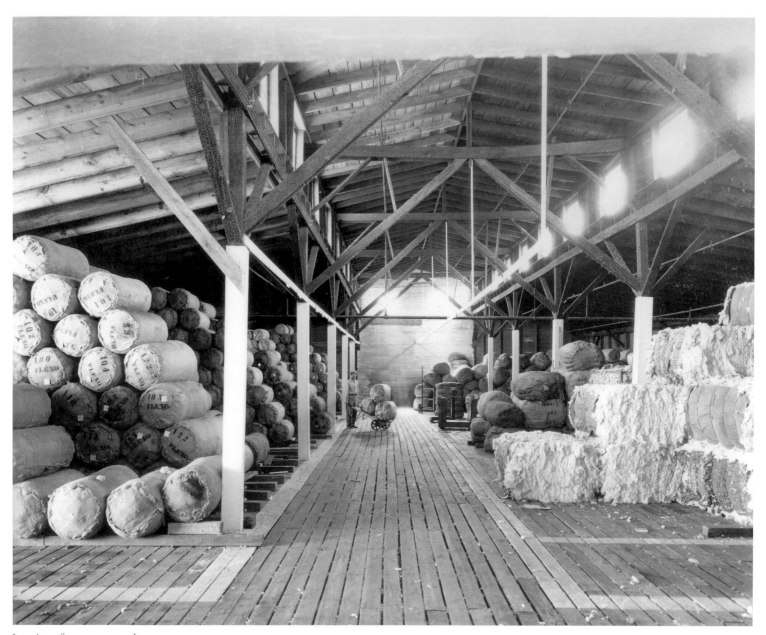

Interior of a cotton warehouse.

THE THRIVING METROPOLIS

1920-1939

The 1920s and 1930s marked a time of remarkable change in Memphis. Many small suburban streetcar towns including Binghamton, Normal and Highland Heights became part of the city. Unfortunately, these sudden changes blurred the lines between residential and commercial properties. In response, the City Planning Commission was formed in 1921 to regulate newly created zoning ordinances, which were later redefined by the Bartholomew Plan of 1924. The Commission's success made Memphis a model for other American cities' planning efforts.

New public construction projects were undertaken as well. The General Hospital added an isolation wing in 1922 and a separate maternity wing in 1924. Also in 1924, Ellis Auditorium was constructed as a venue for conventions, concerts, sports and other entertainment. The newest incarnation of the Orpheum Theatre opened in 1928, replacing the Grand Opera House. Southwestern College was built in 1925 and Memphis Technical High School was completed in 1929. Post-war improvements in aviation brought about the need for the Municipal Airport, which would later prove to be as important as river and rail transportation.

Memphis was the scene of a number of remarkable events in the 1920s. The Universal Life Insurance Company, one of the largest black-owned insurance companies in the nation, was founded in 1923. Tom Lee saved the lives of thirty-two people when the Norman capsized near Memphis in May 1925.

As the Great Depression struck in October 1929, agricultural prices fell and Memphians suffered dearly. In response, local businessmen founded the Cotton Carnival as a way to raise spirits and restore faith in the cotton industry. The success of the Mardi Gras-like festival made it into a permanent annual event.

In the midst of the Depression, one event helped transform Memphis into a modern city. The Tennessee Valley Authority was established in 1933 as part of President Franklin Roosevelt's New Deal program to provide plentiful and inexpensive electricity. E.H. Crump campaigned tirelessly to persuade Memphians to join TVA. His efforts paid off in 1934 when the results of a special election gave officials the authority to purchase the local electrical system from its private owners and link it to the larger network. The process was completed in 1939 when the city purchased the local utility company and renamed it Memphis Light, Gas and Water Division.

Cotton bales being unloaded from a riverboat.

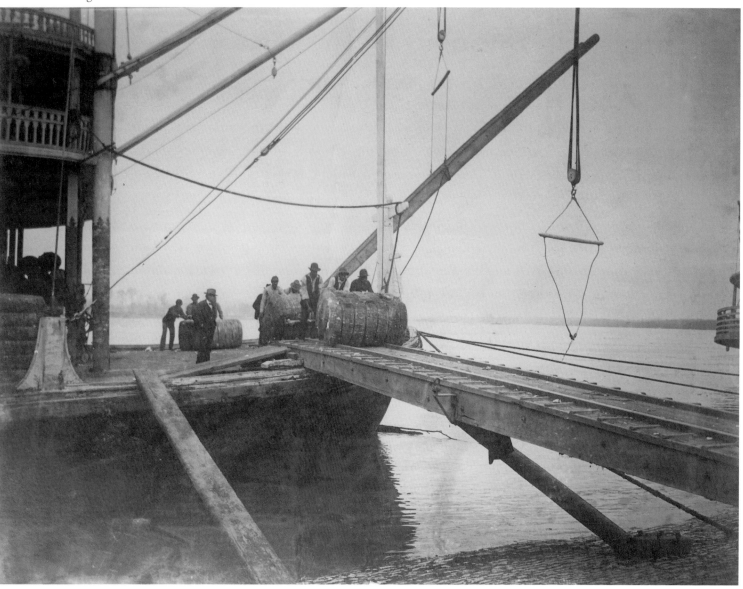

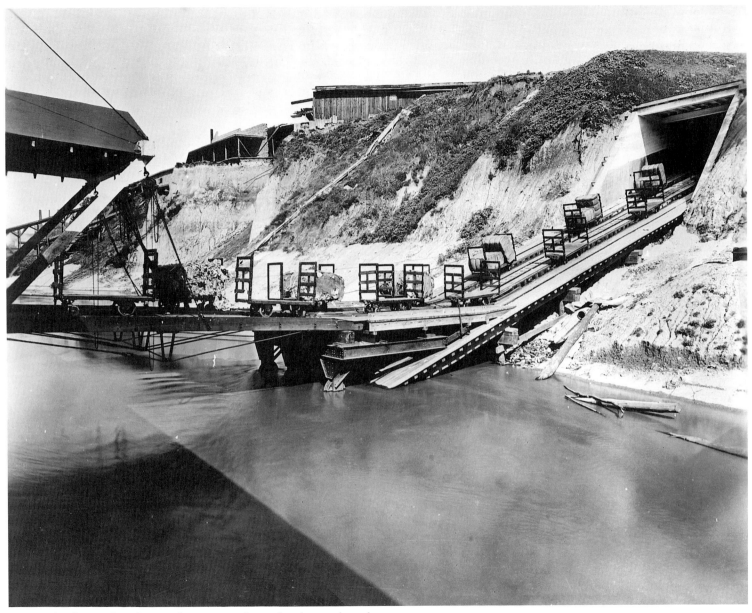

Thousands of tons of products such as cotton, charcoal and canned goods were shipped via barge on the Mississippi River by the Federal Barge Line through the Port of Memphis.

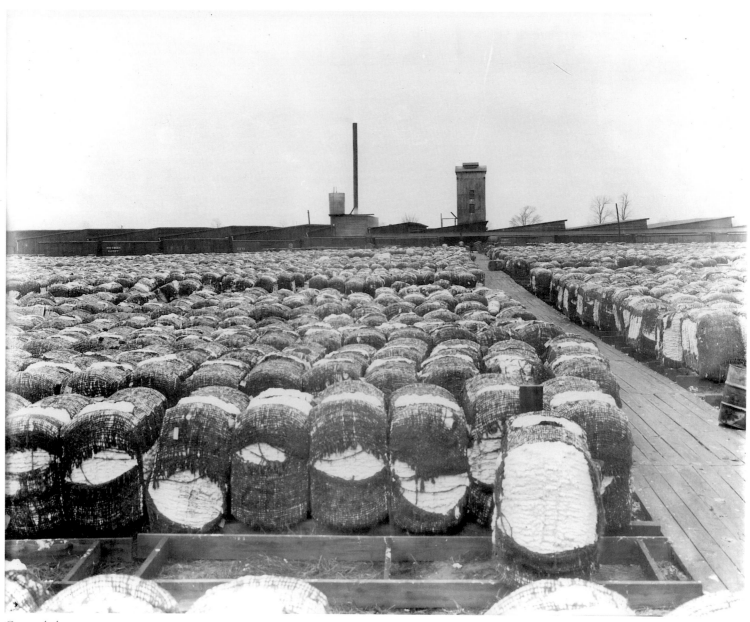

Cotton bales.

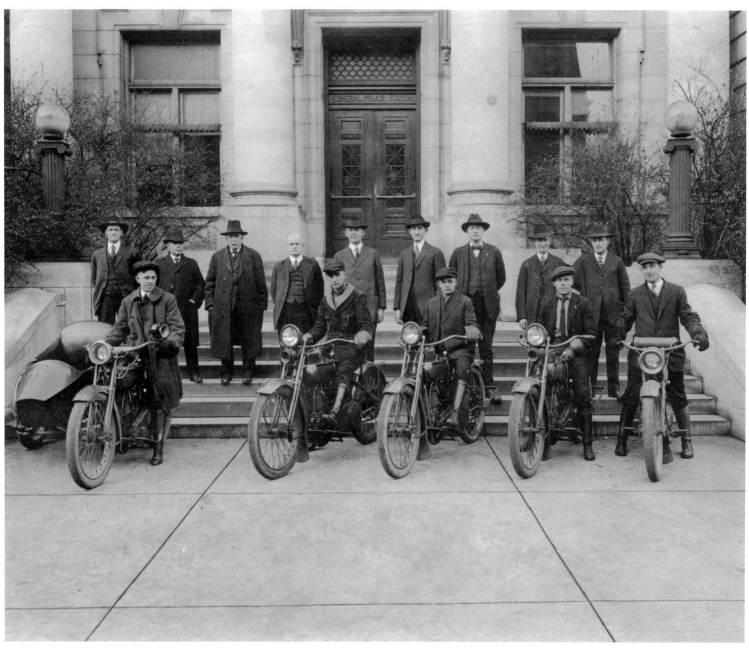

The Motor Cycle and Auto Department of the Metropolitan Police
Department pictured in front of the Central Police Station, 1920.

City Beautiful Commission exhibit in Court Square, 1937. The Memphis City Beautiful Commission was founded in 1930, and inspired Memphians to improve the city with their slogan, "Clean Up, Paint Up, Fix Up." The commission is the oldest city beautification organization in the country.

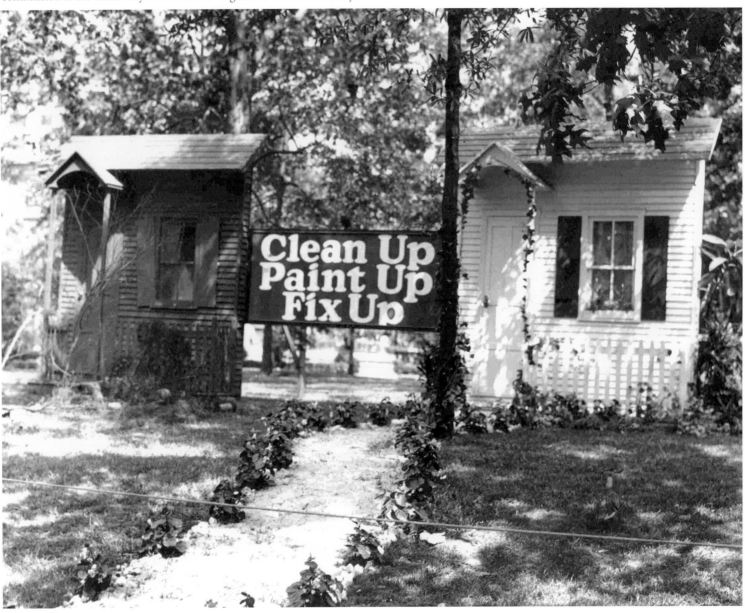

Clarence Saunders, the founder of Piggly Wiggly. Saunders founded his business with one store in 1916, and by 1922, the chain had grown to include over 1,200 stores nationwide.

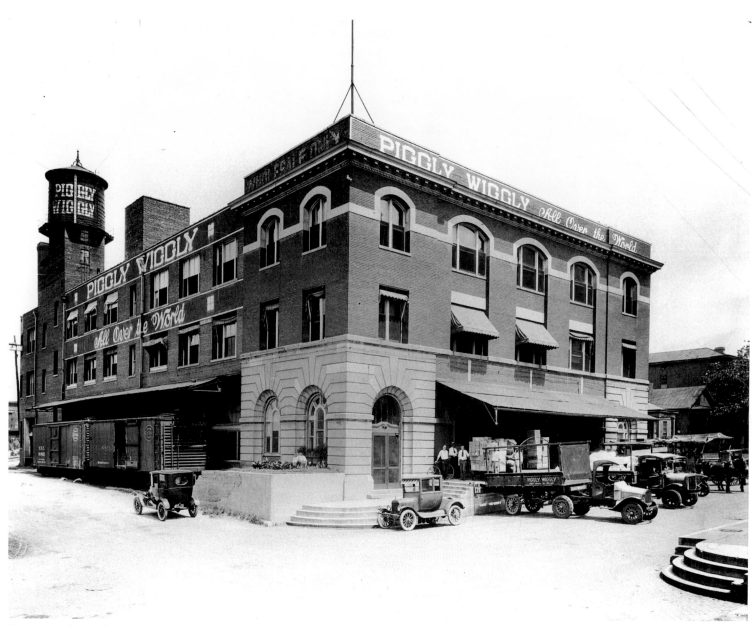

Piggly Wiggly warehouse.

The Pink Palace was originally the home of Clarence Saunders. The city came into possession of the property after Saunders lost his fortune, and it was turned into a museum in 1930.

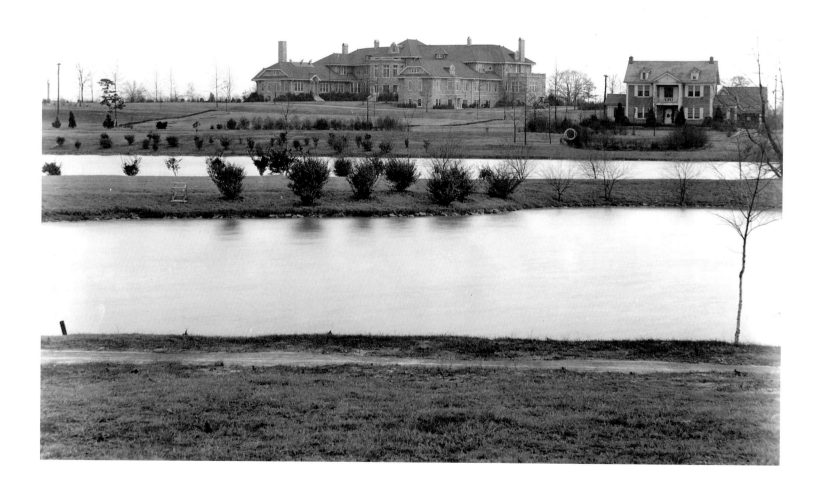

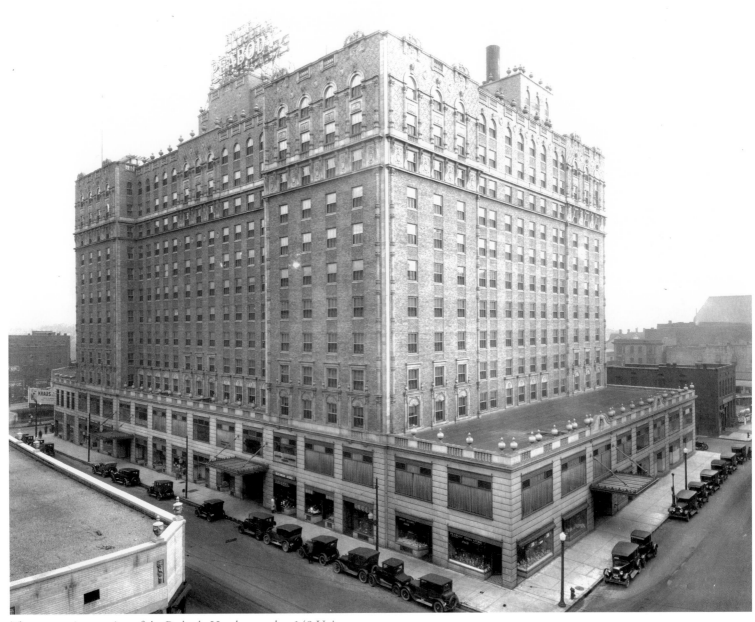

The current incarnation of the Peabody Hotel opened at 149 Union
Avenue in 1925.

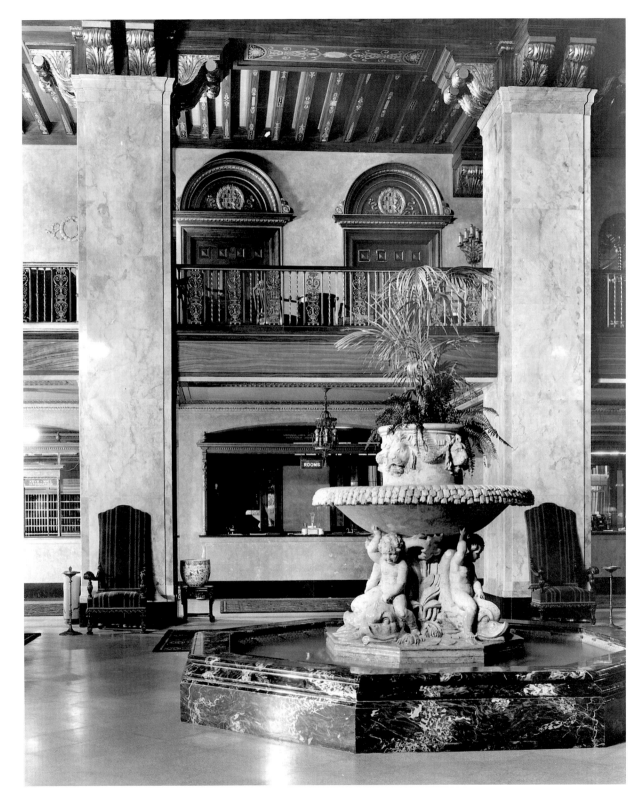

The Peabody Hotel lobby features a Bernini-inspired fountain occupied by live ducks who are escorted from their roof-top roost every morning.

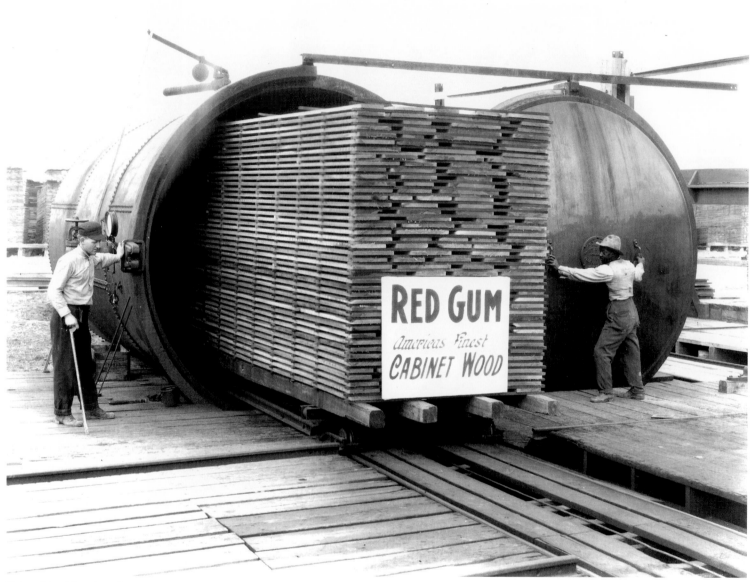

Fisher-Hurd Lumber Company.

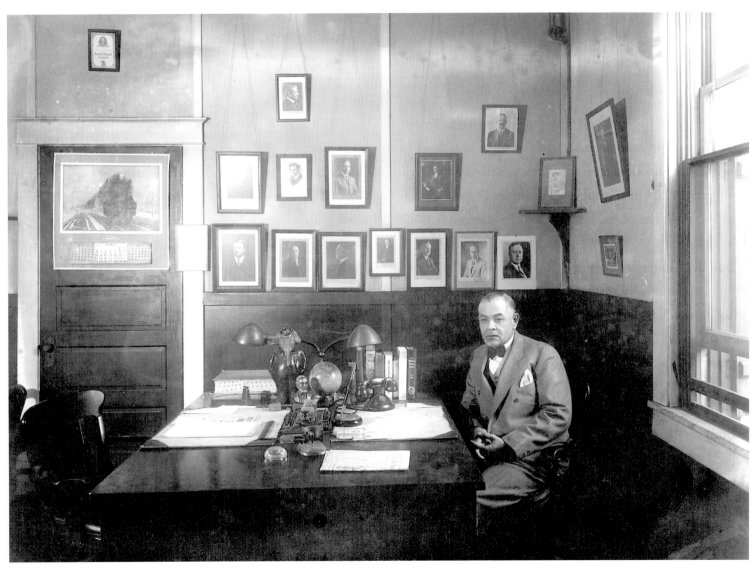

Robert R. Church, Jr., founded the Lincoln League and the Memphis branch of the NAACP. Church also served as a delegate to the Republican National Convention from 1912 to 1940.

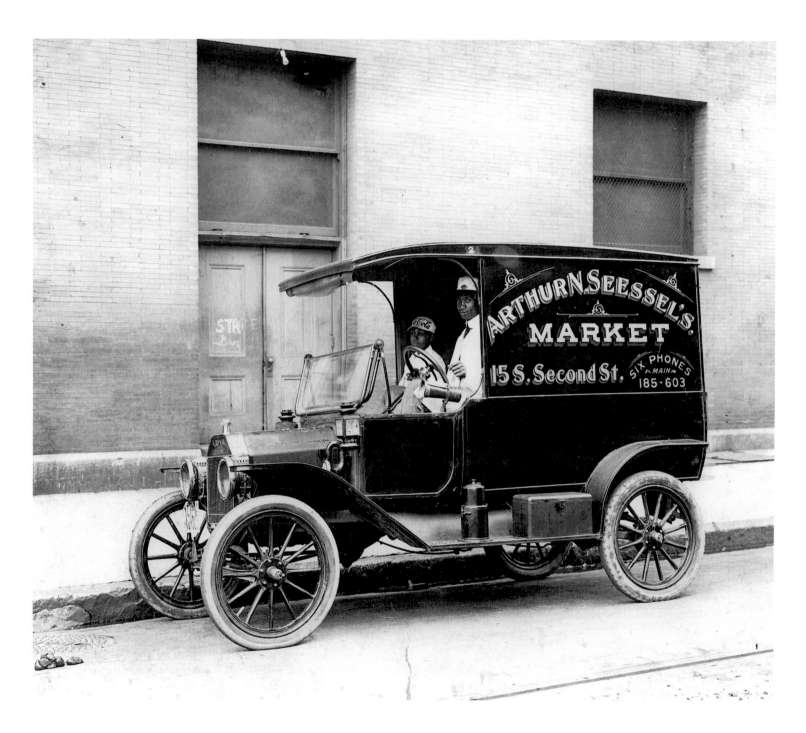

Arthur Seessel moved his family's butcher business to 15 South
Second Street in 1909. In 1912, he began using gasoline-powered
trucks to deliver his goods. Seessel's Grocery stores continued to
deliver items to customers' homes until 1965.

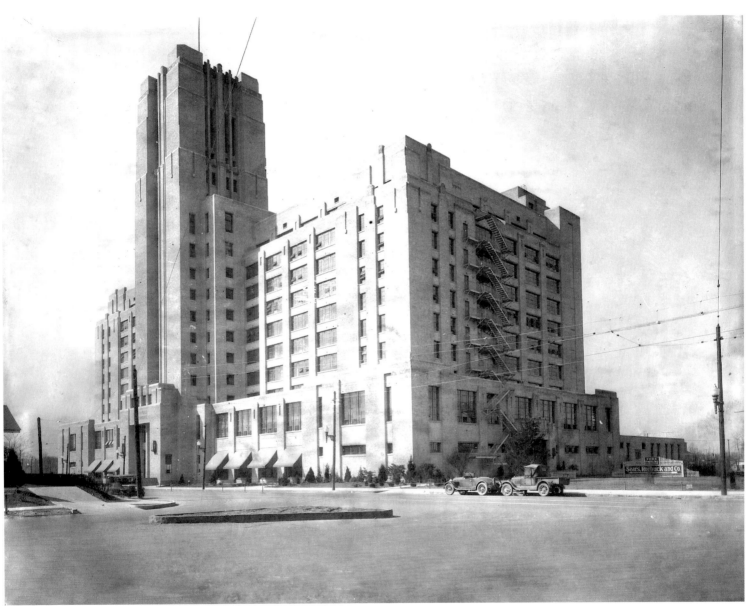

Sears and Roebuck opened this building at 497 Watkins in
1927. It was used as a credit operations and catalog merchandise
distribution center in addition to operating as a retail store.

A typical cotton gin where cotton was processed and packaged.

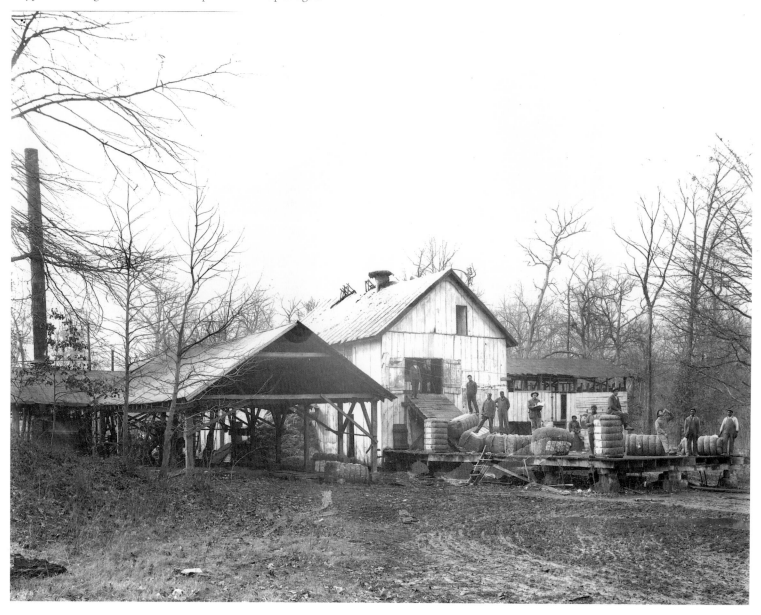

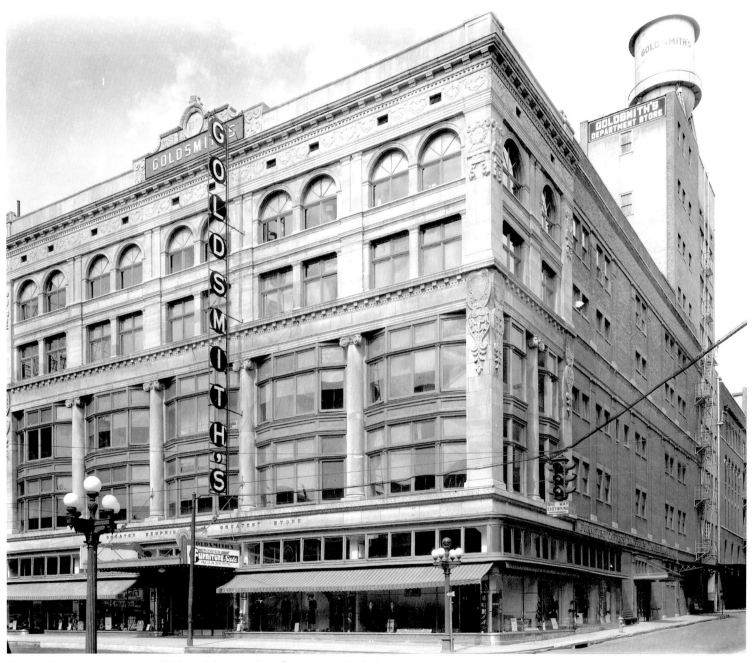

German-born Jacob and Isaac Goldsmith bought their first store on Beale Street in 1870 and a second on Main in 1881. In 1901, Jacob moved operations into this building at 123 South Main after Isaac's death.

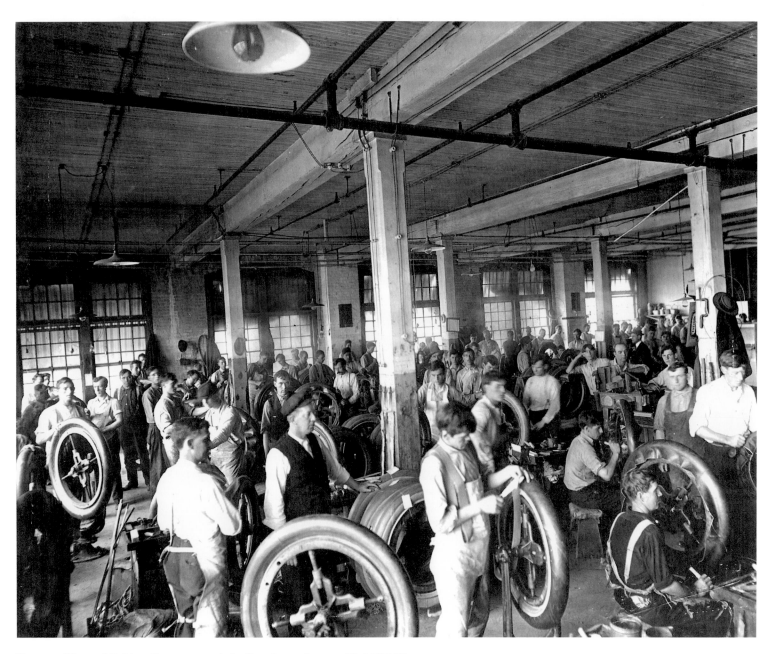

Firestone Tire and Rubber Company made its first tire on January 19, 1937. The eighty-five acre North Memphis facility operated until 1983.

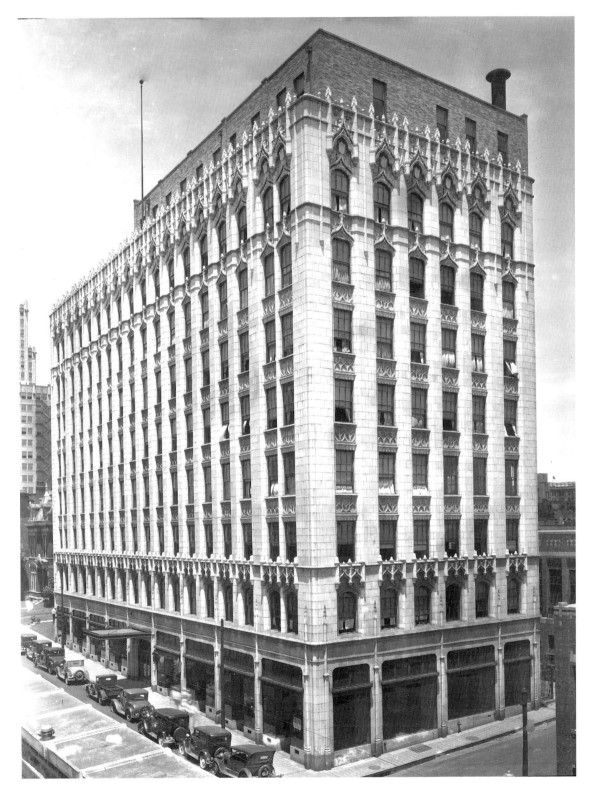

The Medical Arts Building was built in 1924. It was purchased in 1952 and renamed the Hickman Building by *Cotton Trade Journal* president Francis Hickman and his sister Jane Hickman.

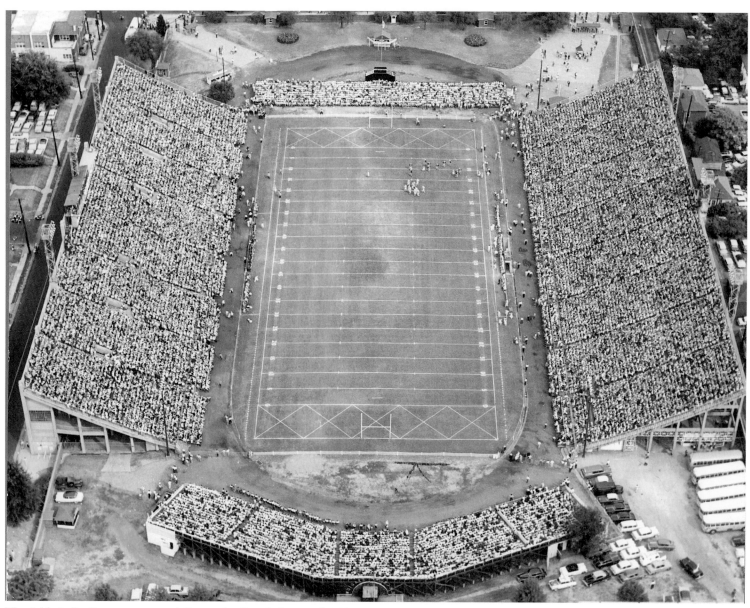

The Athletic Stadium was renamed Crump Stadium in honor of E. H.
Crump shortly after its completion in 1934.

106

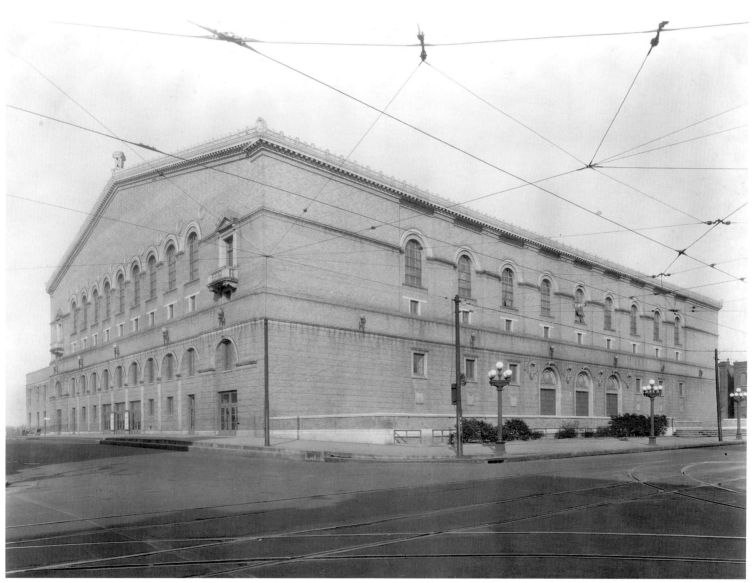

Ellis Auditorium was built on the site of Market Square. John Philip Sousa led the band at the opening ceremony on October 17, 1924. The last performance was given by Bruce Springsteen on November 19, 1996.

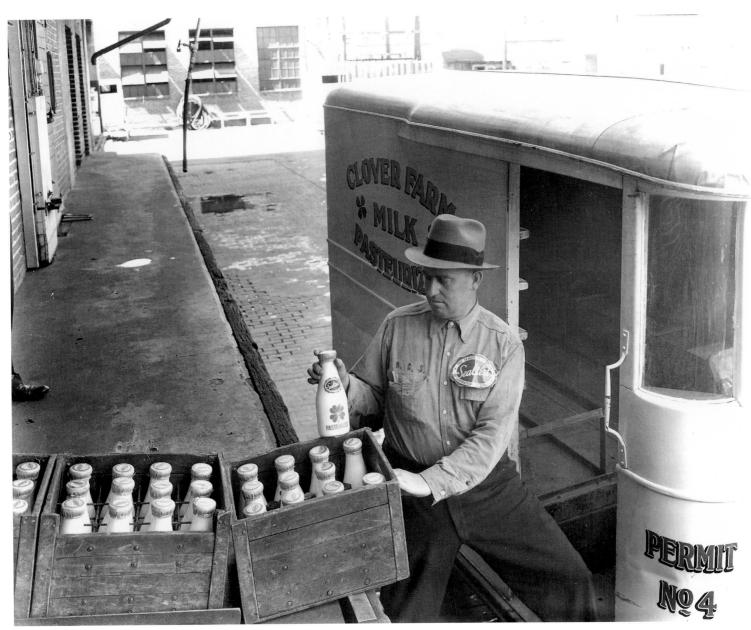

Clover Farm Dairy Company traced its origins back to Major Thompson's 1871 dairy farm. The Memphis Pure Milk Company bought the operation in 1905 and pioneered local efforts in dairy pastuerization and refrigeration.

First National Bank, now First Tennessee, occupied this building until 1961. The Goodwyn Institute moved into the old bank building, while the bank bought the institute's property, demolished the building, and built a new bank on the site.

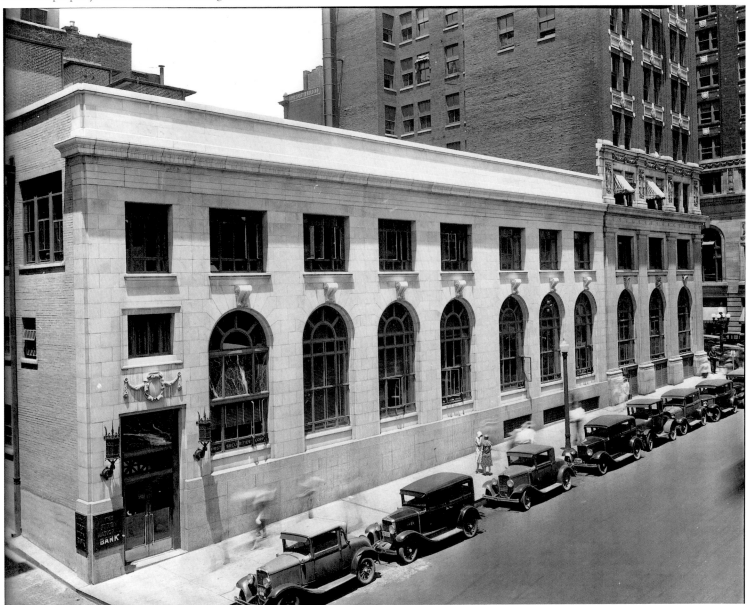

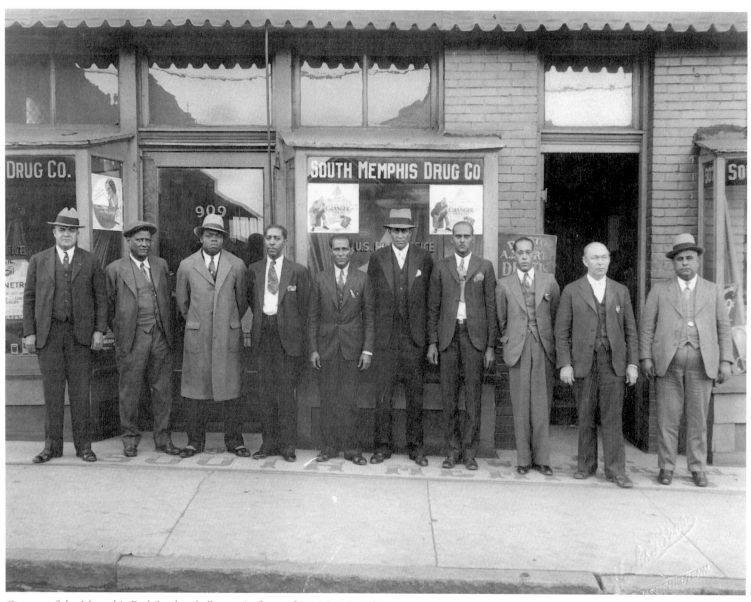

Owners of the Memphis Red Sox baseball team in front of Dr. J.B. Martin's
South Memphis Drug Company on Florida Street.

The Shelby County Court House at 140 Adams, completed in 1909.

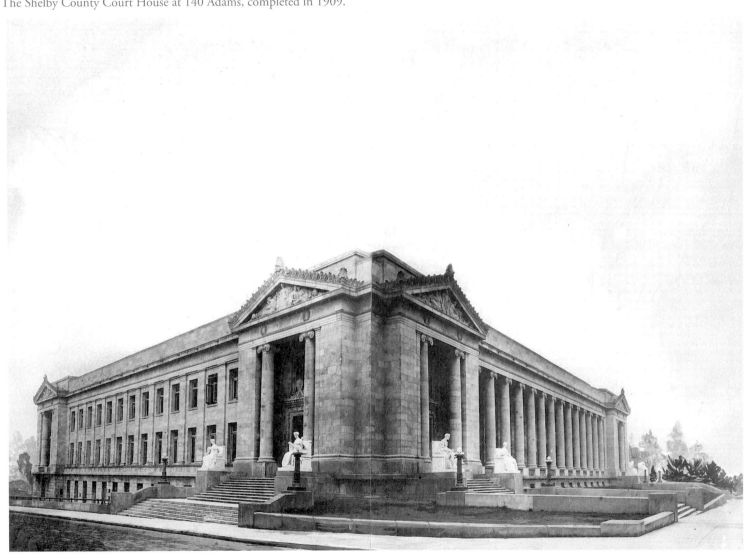

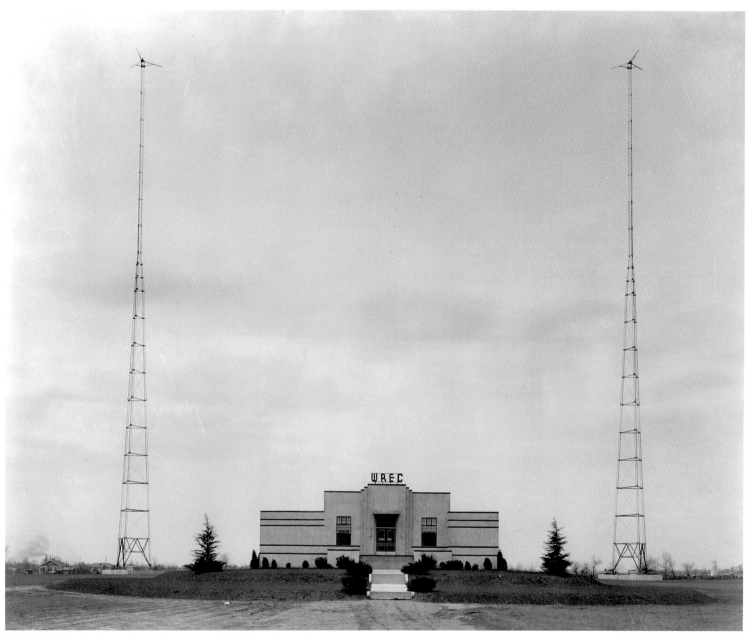

WREC Radio Station at Payne Avenue and Hindman Ferry Avenue,
circa 1936.

The Beale Street Markethouse and Cold Storage Plant was razed and replaced by
Beale Street Park in 1930. In 1931, the park was renamed Handy's Park in honor
of the famous composer W.C. Handy.

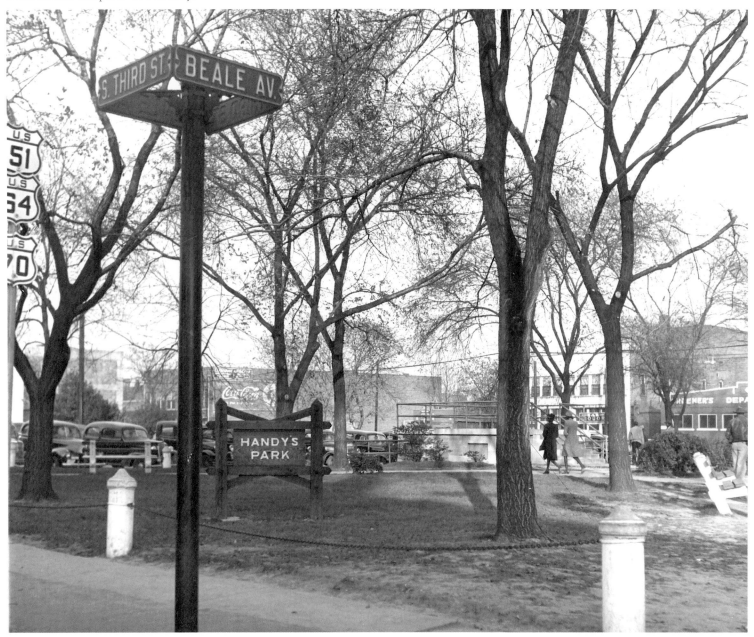

The Colored Old Folks Home was built by Dave
Washington, who was the first African American
Memphian appointed to the U.S. Postal Service.

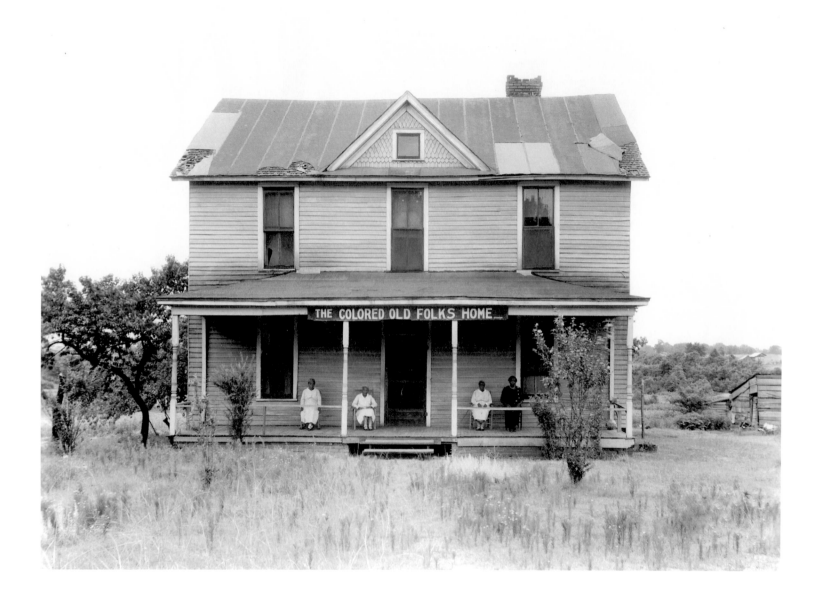

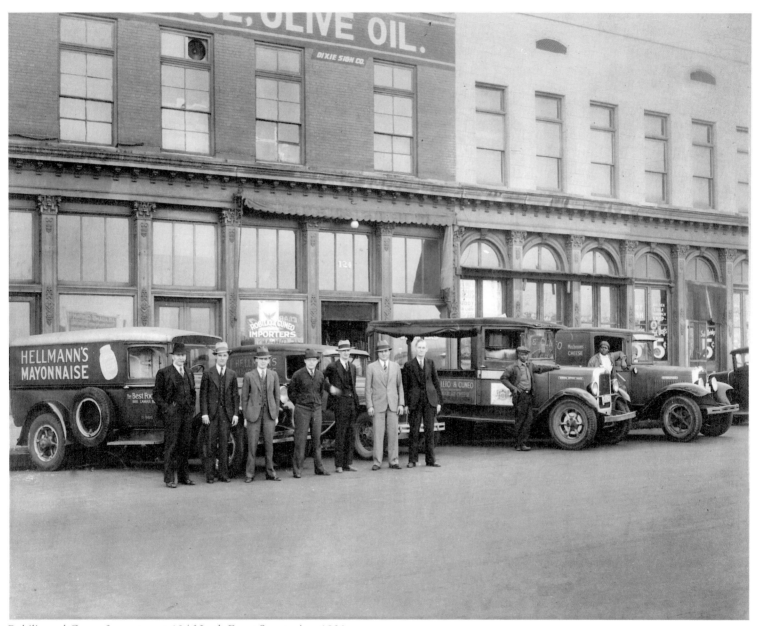

Robilio and Cuneo Importers at 124 North Front Street, circa 1931.
John Robilio opened his first grocery store at Jackson and Alabama in
1909, two years after arriving from Italy. He partnered with Thomas
Cuneo in 1929 to form Ronco, a pasta manufacturer and import
business.

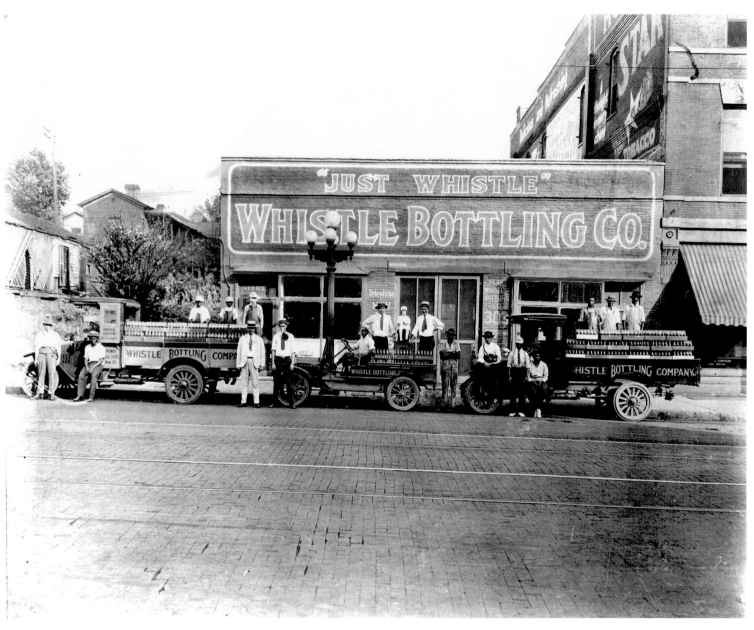

Whistle Bottling Company at 303-307 South Main, circa 1919.

A Cotton Carnival procession passing Court Square in 1937.

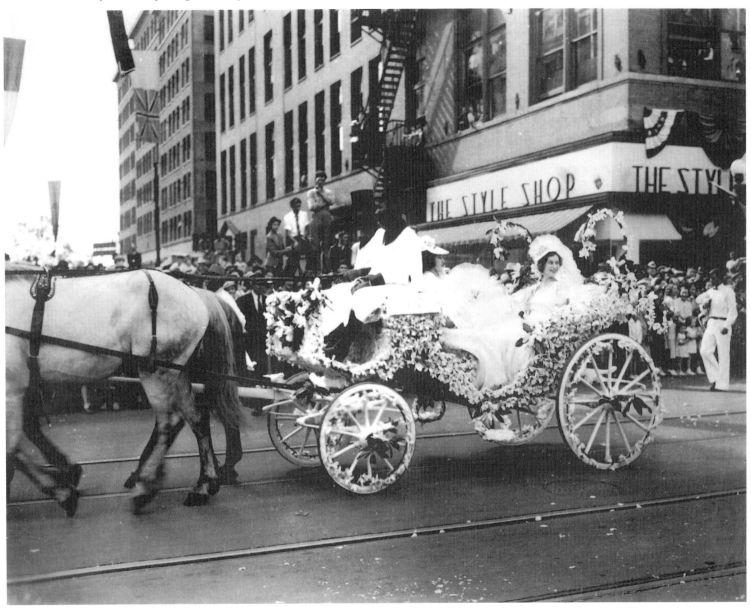

The Cotton Carnival King and Queen escorted by Boy Scouts, 1937.

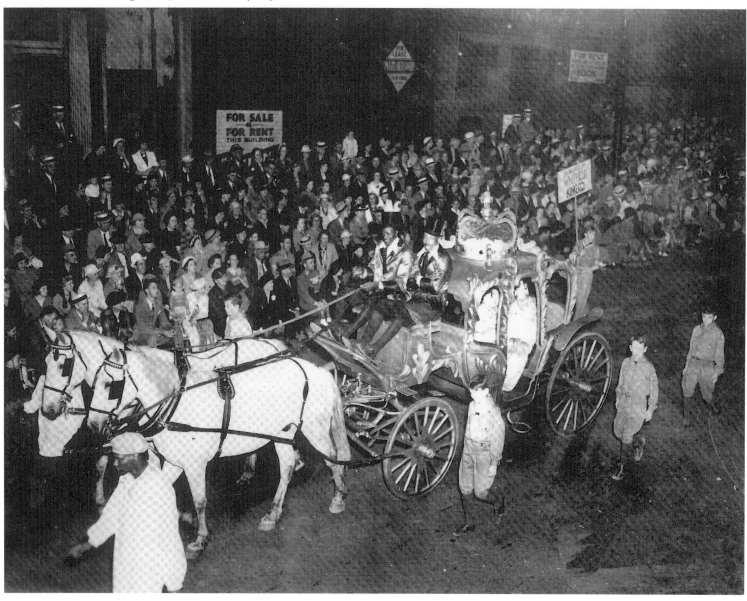

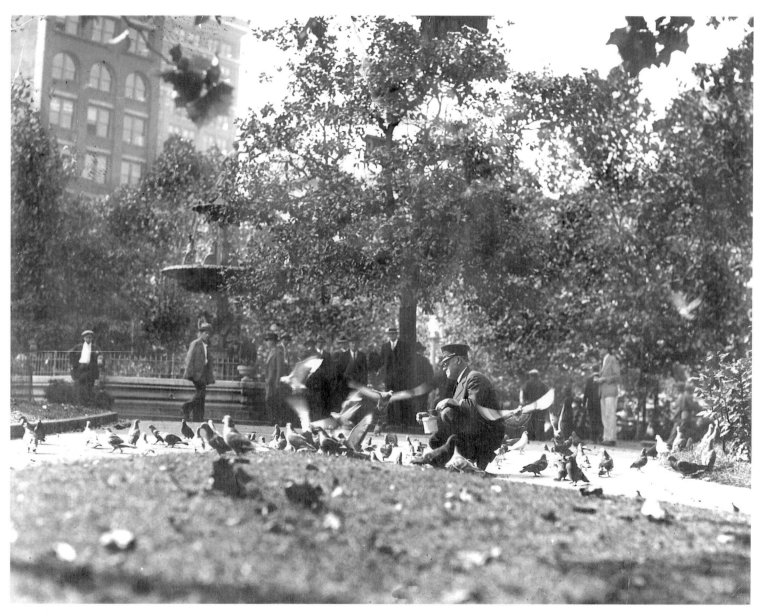

Scene from Court Square, 1932.

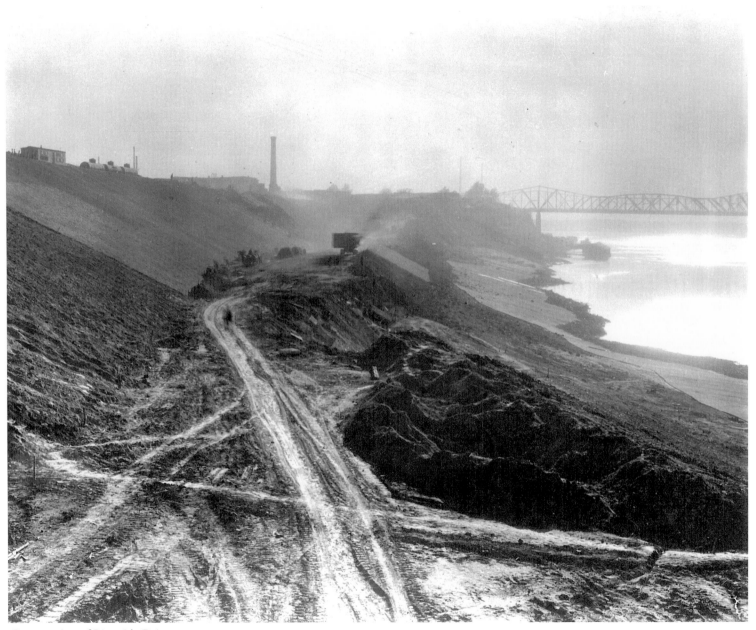

Construction of Riverside Drive.

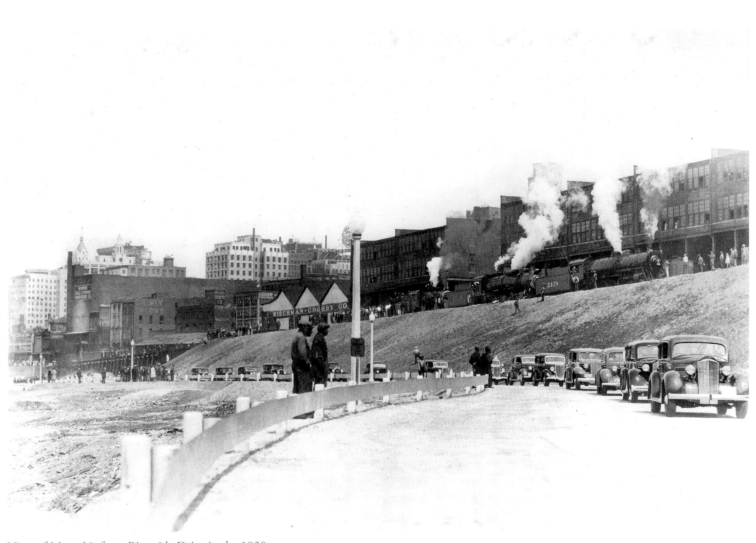

View of Memphis from Riverside Drive in the 1930s.

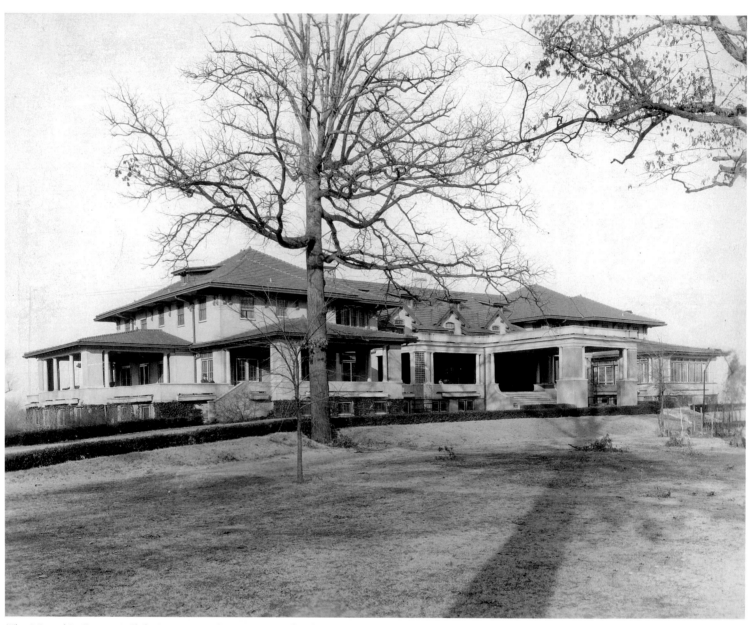

The Memphis Country Club, incorporated in 1905, was first located in the former home of Geraldus Buntyn. The second club building, pictured here, was built after the first burned in 1910. This facility was demolished and replaced by a new building in 1958.

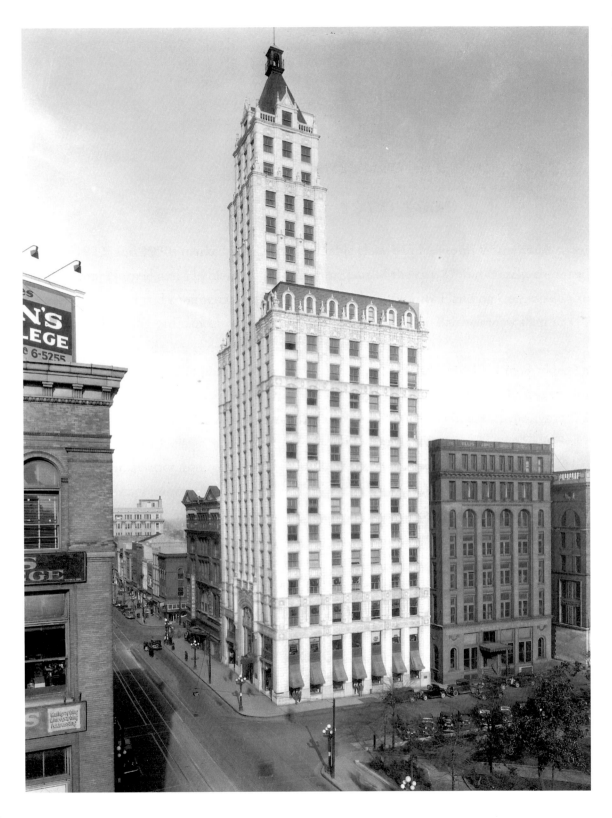

The Columbia Mutual Tower, later named the Lincoln-America Tower, 1935.

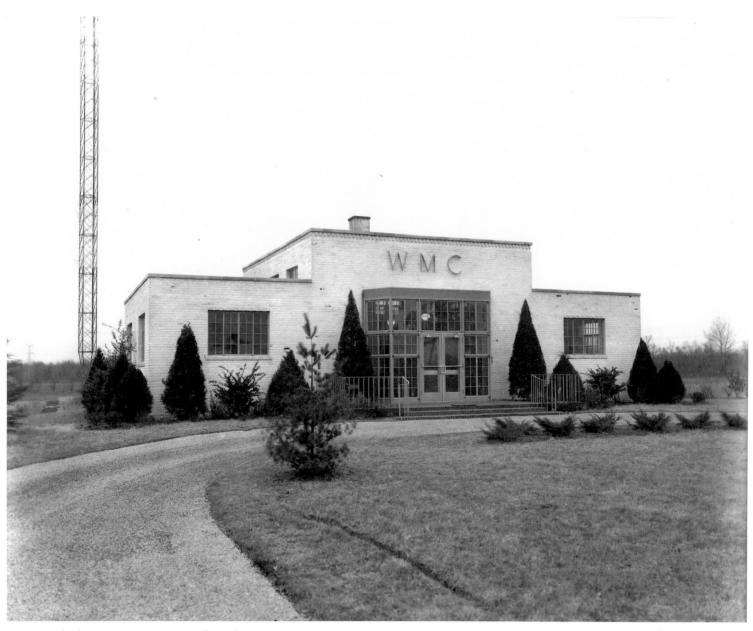

WMC Radio began operating in 1923 from the Commercial Appeal Building and moved into a facility on Highway 70, pictured here, in January 1930. The FCC forced the station to close in December of 1930, but it was able to resume operations from the Gayoso Hotel in September 1931.

Bry's Department Store, 1936.

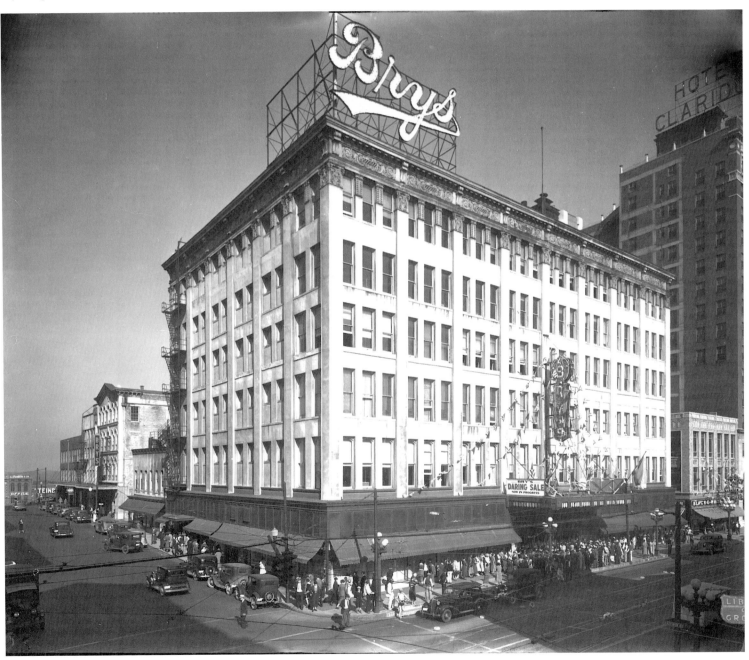

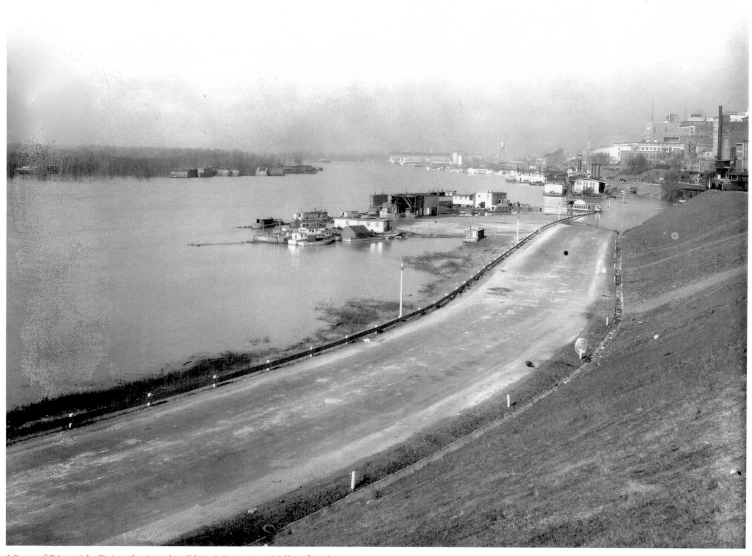

View of Riverside Drive during the Ohio-Mississippi Valley flood of 1937. Water covered Riverside where it meets Beale Street.

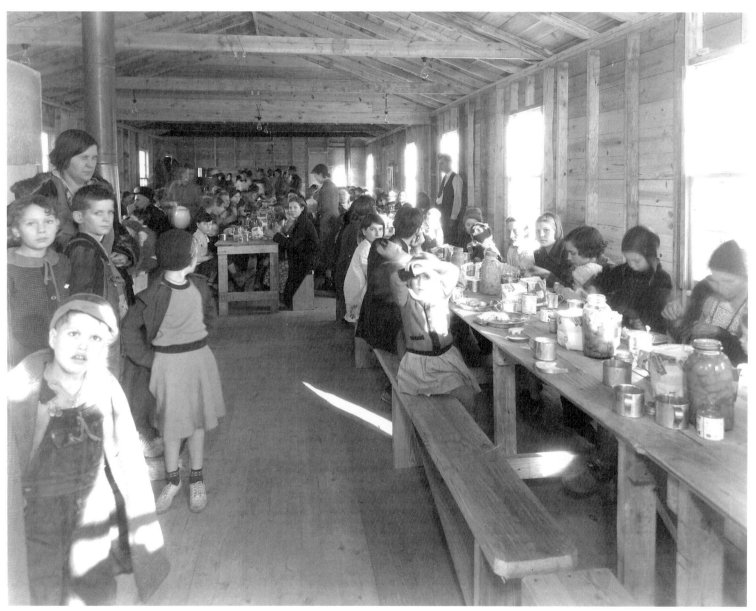

A view of the mess hall at the make-shift refugee camp at the
Fairgrounds during the flood of 1937.

Main and McCall, circa 1939.

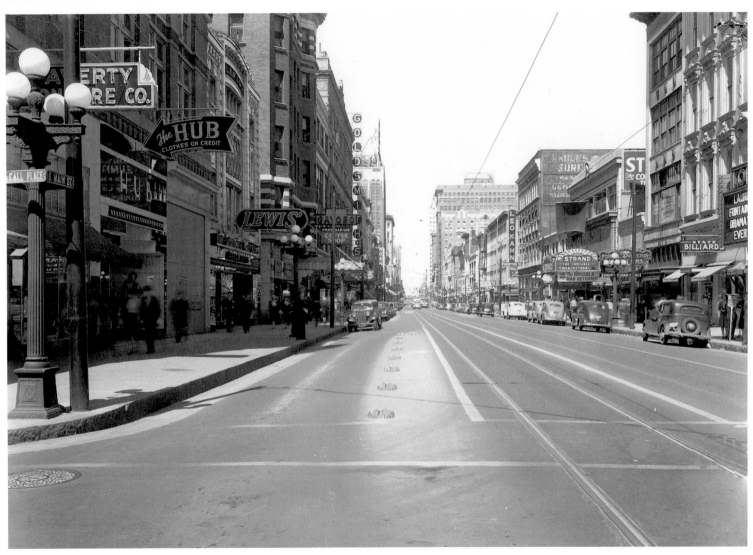

A City on the Move

1940-1959

Memphis and Shelby County played a major role in U.S. efforts during WWII. Chickasaw Ordnance Plant was built in 1940 and a naval air station was opened in Millington in 1942. The next year, the Army Defense Depot and Mallory Air Force Depot were built. Local companies including Firestone Rubber Company, Ford Motor Company and Fisher Auto Plant were converted to war material production. Lieutenant George Lee raised money in the African American community to purchase a bomber named *The Spirit of Beale Street.* A number of aircraft were named for a city by their crews, but the most famous was the *Memphis Belle.* She was the first B-17 to complete 25 missions over Europe with her original crew.

The city grew as a distribution hub in the post-war years. In 1948, President's Island was transformed from an untamed river island into a multi-million dollar industrial complex. River commerce increased from 3.5 million tons per year to approximately eight million tons over the next twenty years. By 1952, there were nine railroad trunk lines, seventeen rail lines, eighty trucking lines and seven airlines operating out of Memphis. Boosters proudly advertised the city's hospitable business environment and high standard of living to encourage businesses to expand or relocate to Memphis. Memphis was named America's quietest, cleanest and safest city several times in the 1950s.

Ironically, while Memphis was the quietest city, it was also host to a musical revolution. Sam Phillips opened the Memphis Recording Studio, later named Sun Record Company. Phillips recorded African American rhythm and blues music by James Cotton, Rufus Thomas, Rosco Gordon, Little Milton, Bobby Blue Bland, B.B. King and Howlin' Wolf. The studio continued its success with Charlie Rich, Jerry Lee Lewis, Johnny Cash, Roy Orbison, Carl Perkins, and of course, Elvis Presley.

This music revolution began in the 1950s and continued through the following decades. The 1960s and 1970s saw the rise of a number of influential recording studios. Stax, began in 1958 and was home to the Mar-Keys, Booker T and the MGs, Sam and Dave, Otis Redding and Isaac Hayes. Willie Mitchell of Hi Studio recorded Al Green and Ann Peebles in the 1970s, while Ardent recorded Alex Chilton and Big Star and remains a popular studio today.

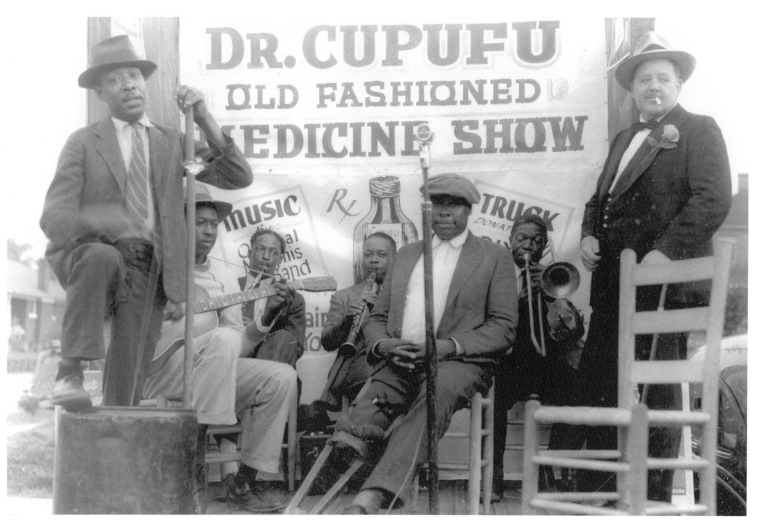

The Dr. Cupufu Old Fashioned Medicine Show at a
City Beautiful rally in 1942. Dr. Cupufu stands for the
organization's slogan, "Clean Up, Paint Up, Fix Up."

Main and Beale Street, 1940.

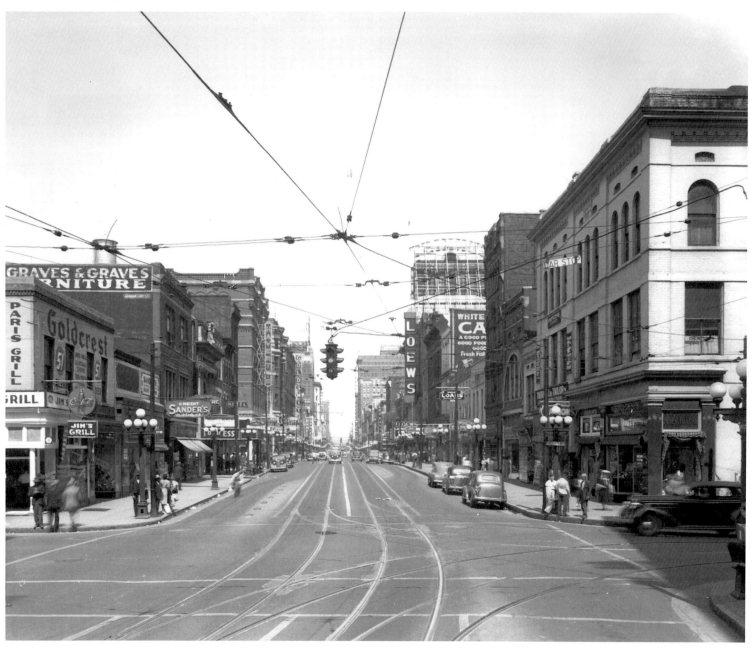

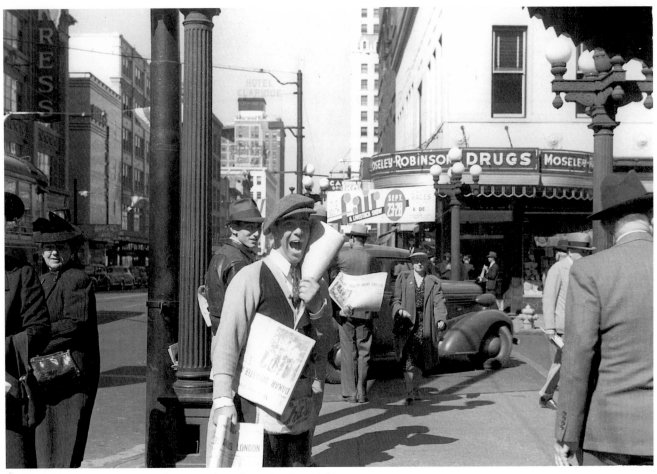

Newspaper boy on the corner of Main and Madison Avenue, 1940.

W.C. Handy wrote some of his most memorable songs while in Memphis.
A park on Beale Street was named in his honor, as well as a theater in the
Orange Mound neighborhood.

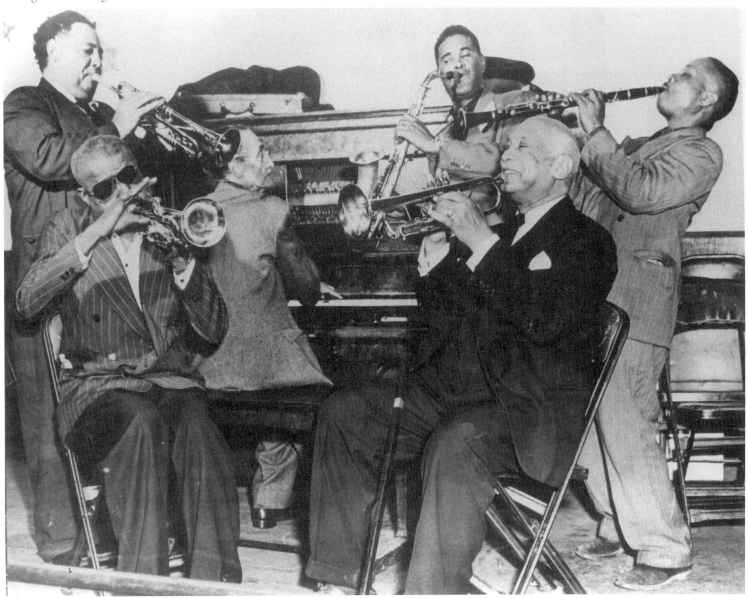

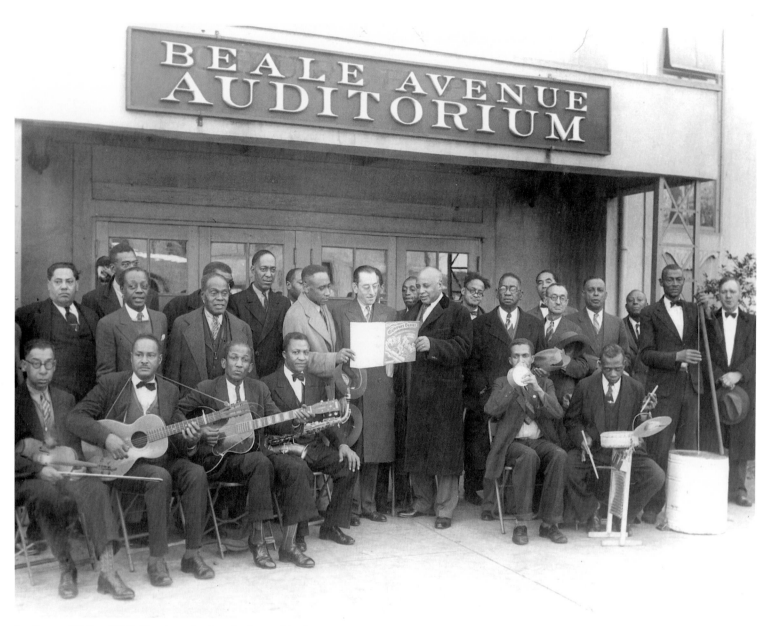

Lt. George W. Lee, W.C. Handy and others in front of Beale Avenue
Auditorium in the 1940s. In 1909, W.C. Handy wrote "Mister Crump"
about mayoral candidate E.H. Crump. It became his first important song
when it was published in 1912 as "Memphis Blues."

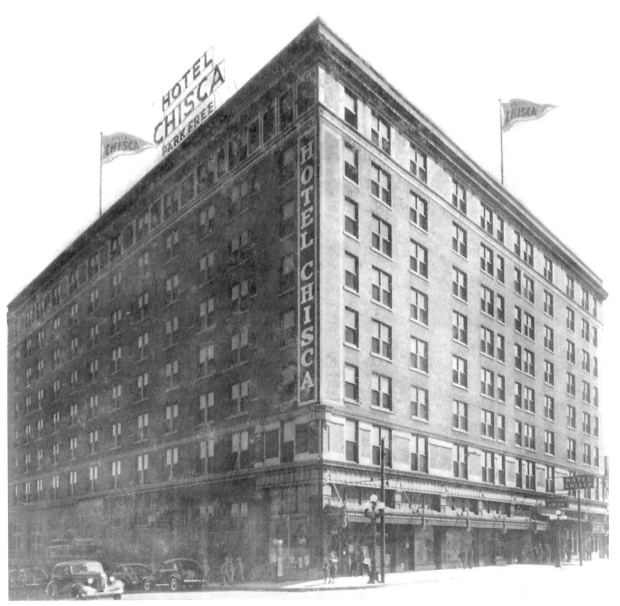

The Hotel Chisca, 1940. The Chisca opened in 1913 and expanded in
1959. The Church of God in Christ acquired it in 1972.

East Memphis Motor Company, formerly East End Motor Company, 1940s.

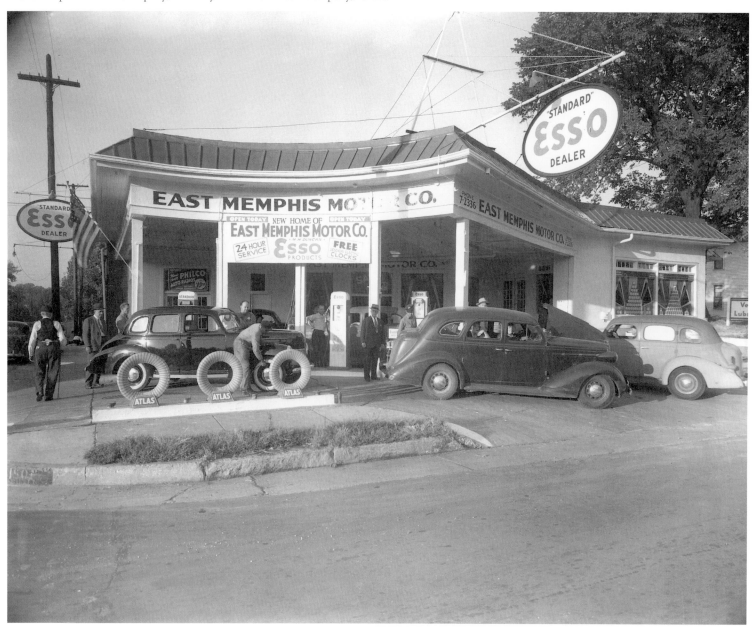

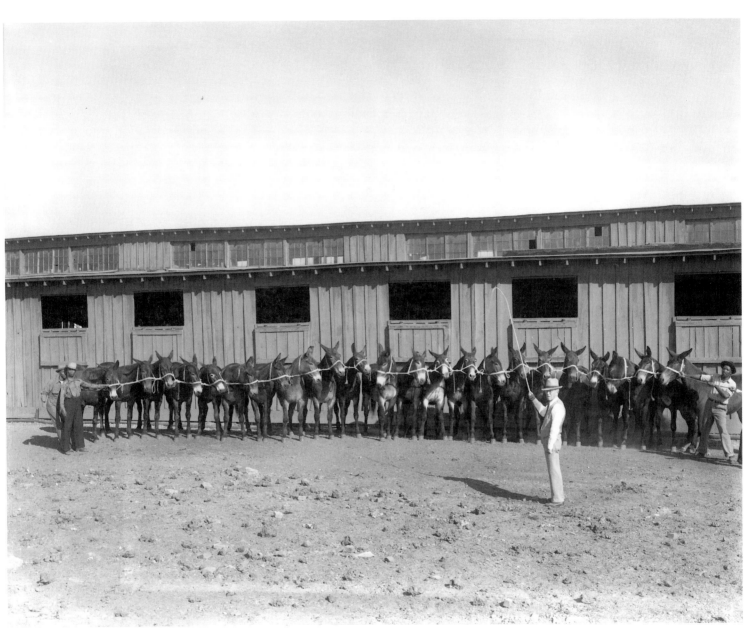

Smith-Podesta Horse and Mule Company at 190 McLemore, 1940. Memphis was considered the largest mule trading market in the country during the first part of the twentieth century.

Streetcar passing Bry's Department Store, 1940.

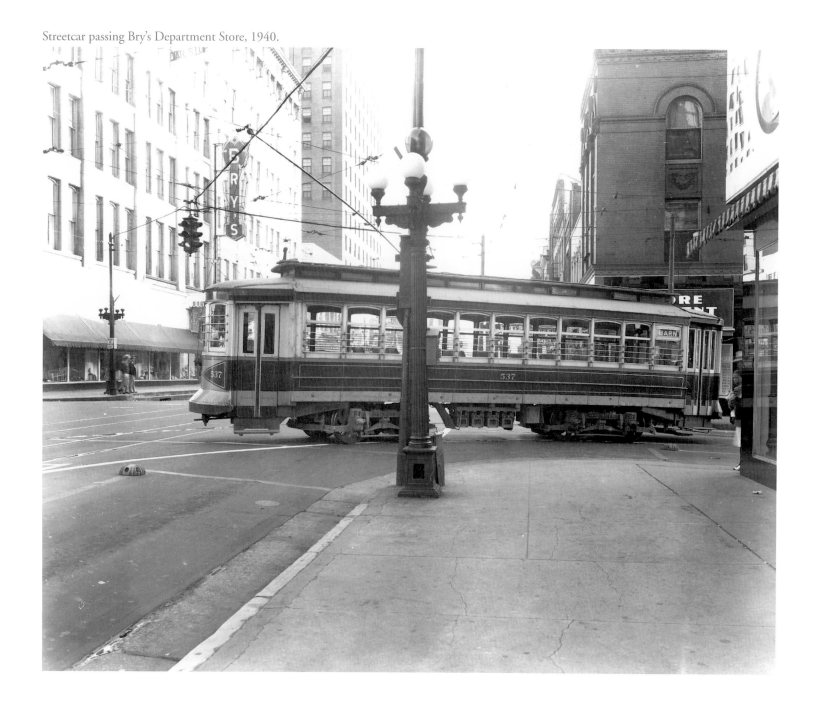

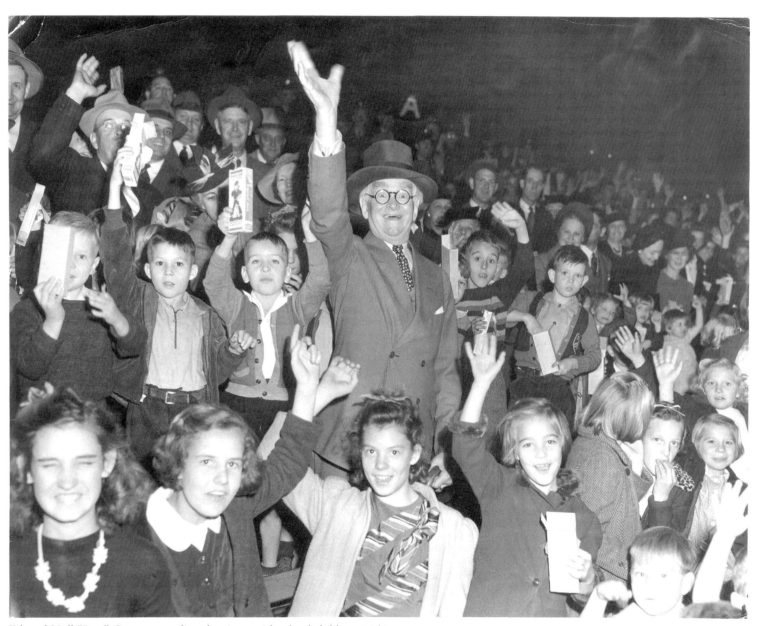

Edward Hull "Boss" Crump attending the circus with school children, 1942.

Workers making repairs
to streetcar lines, circa
1946.

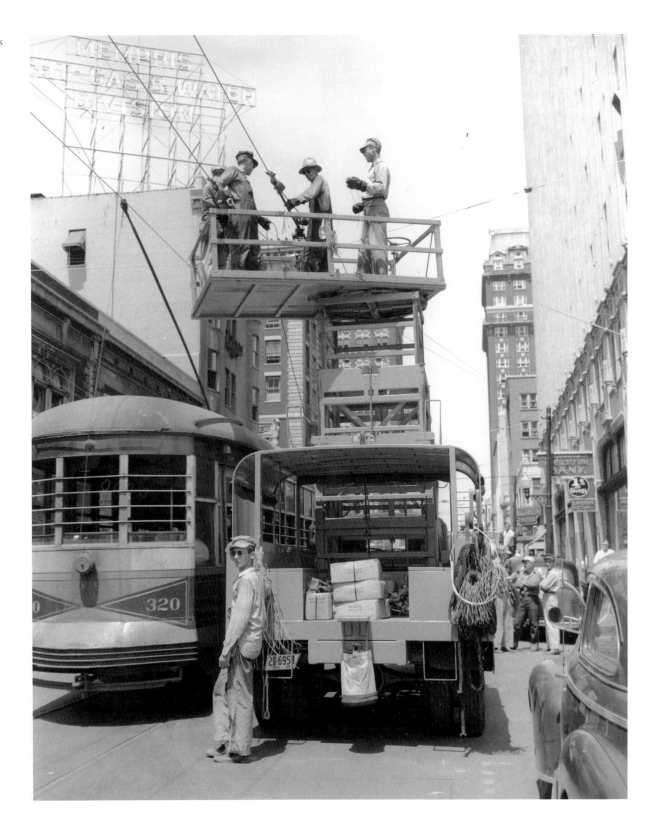

Booker T. Washington High School marching band, 1943.

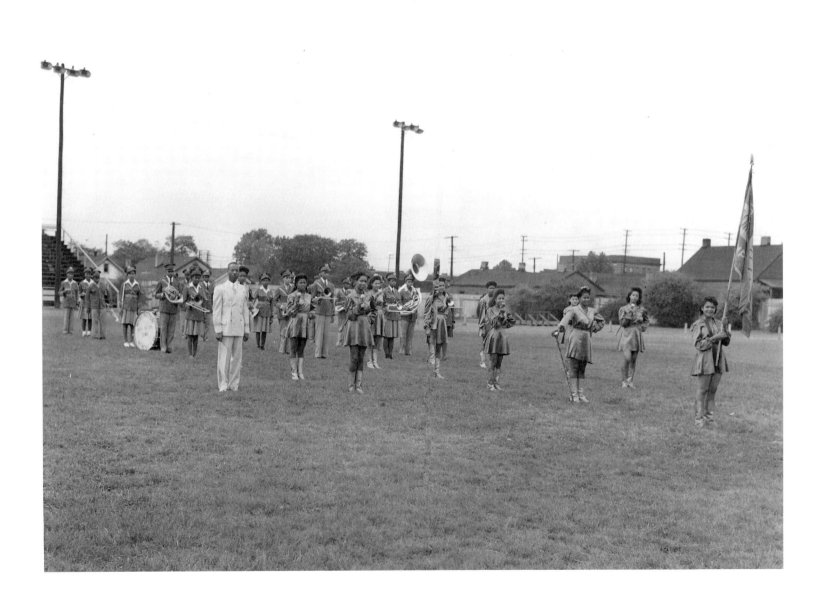

The B-24 Liberator purchased through a fund-raiser led by Lt. George
W. Lee during World War II.

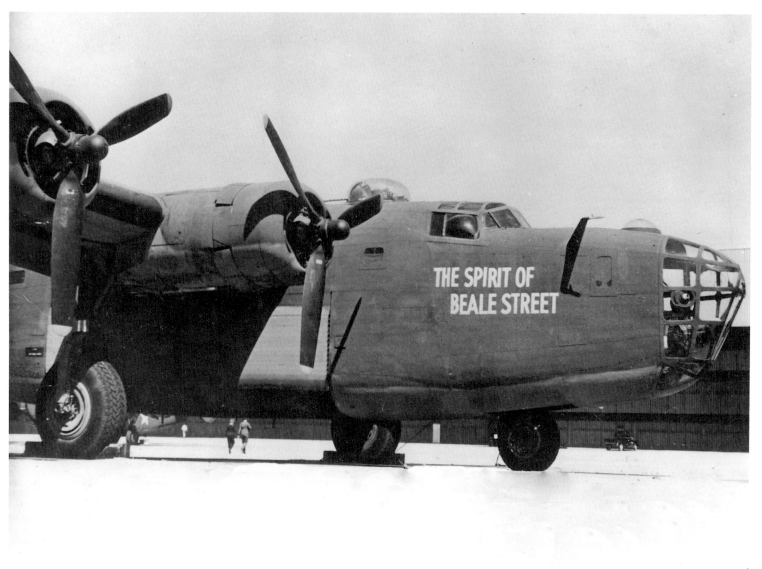

Bemis Brothers Bag Company, 1943. The St. Louis-based company
opened a bag factory in Memphis in 1900.

Mayor Watkins Overton appointed Lloyd T. Binford to the Shelby County Board of Censors in 1928. Binford was notorius for banning films based on his personal prejudices during his 25 years of service on the board.

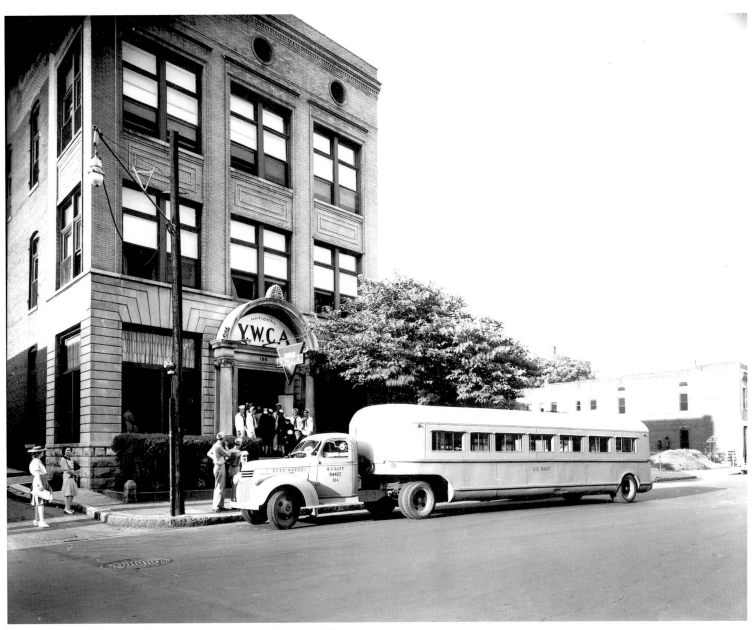

The YWCA Building at 196 Monroe Avenue, 1943. A new building
was completed in 1951 at 200-202 Monroe Avenue, which later became
home to the Salvation Army.

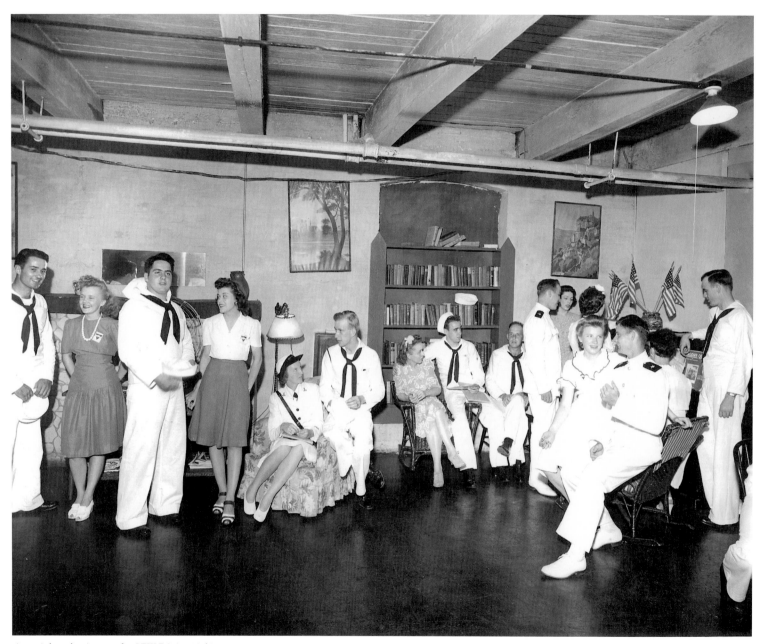

A social gathering at the YWCA in 1943.

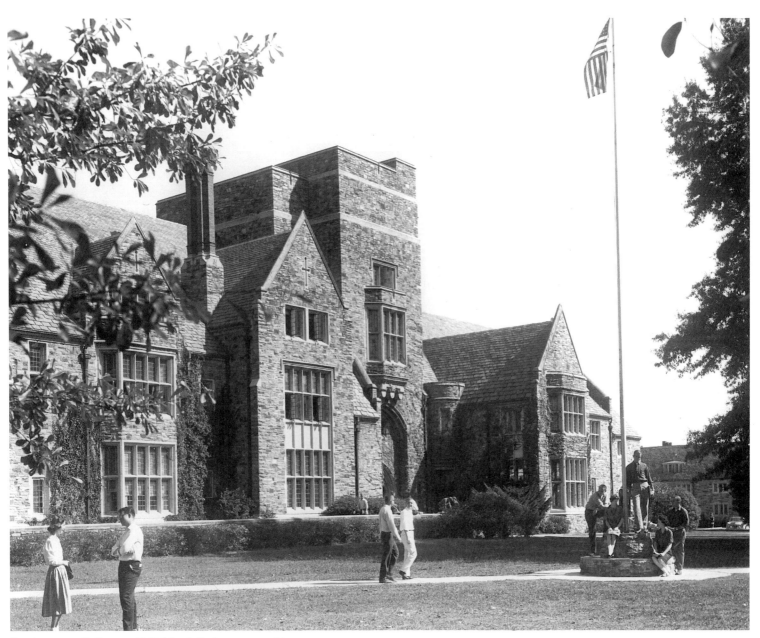

Southwestern College at 2000 North Parkway opened in
1925. The name was changed to Rhodes College in 1984.

View of Union Avenue and Riverside Drive near the Mississippi River in 1944.

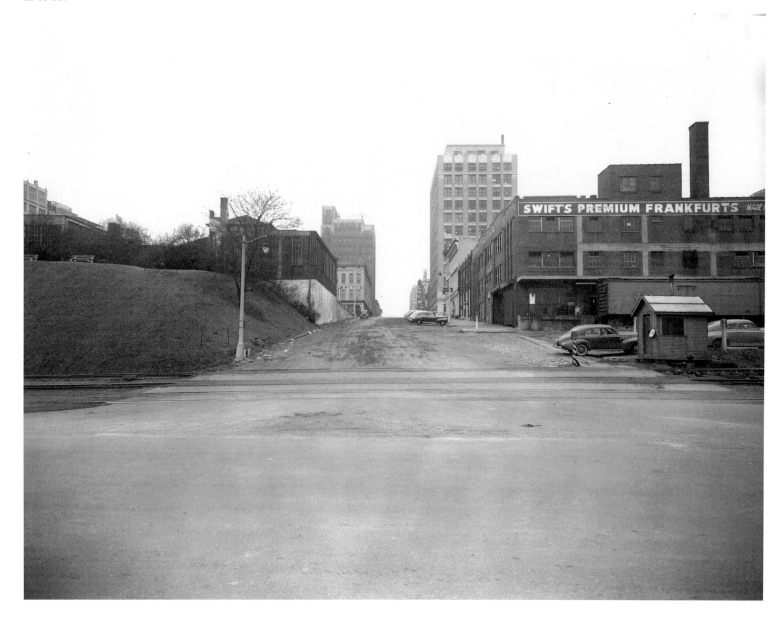

Cotton Exchange, 1944.

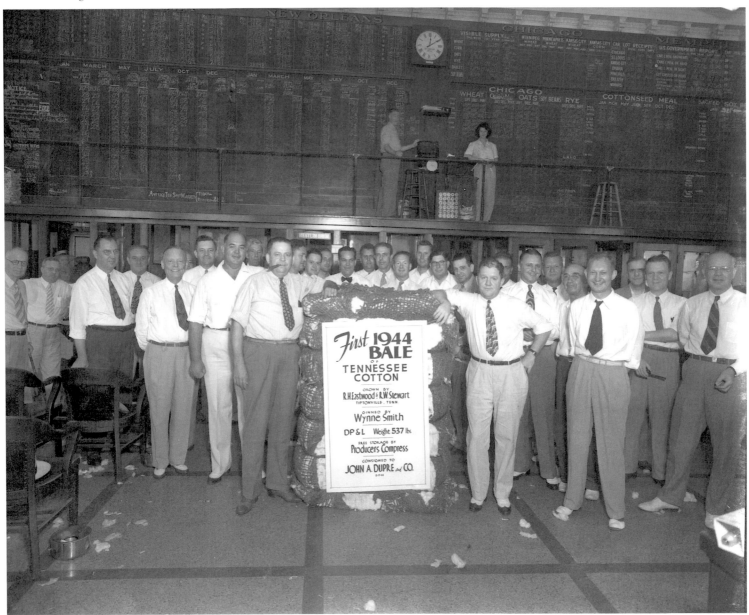

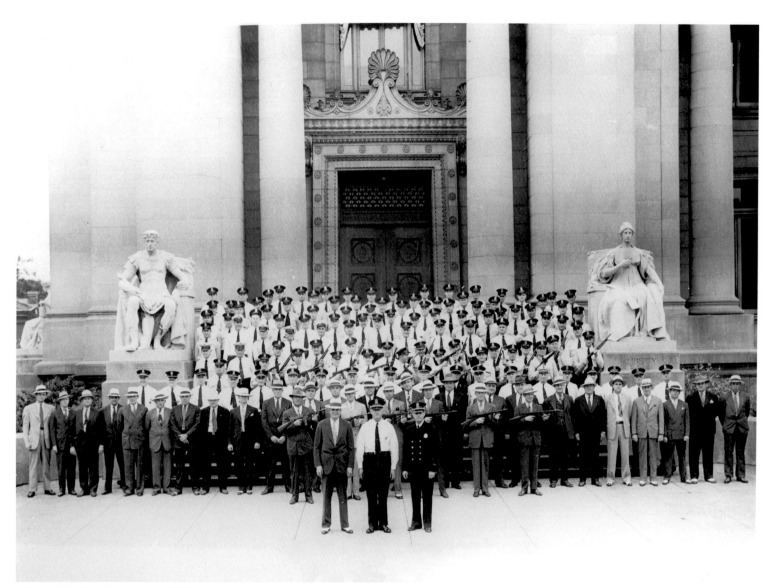

Memphis Police Department, 1944.

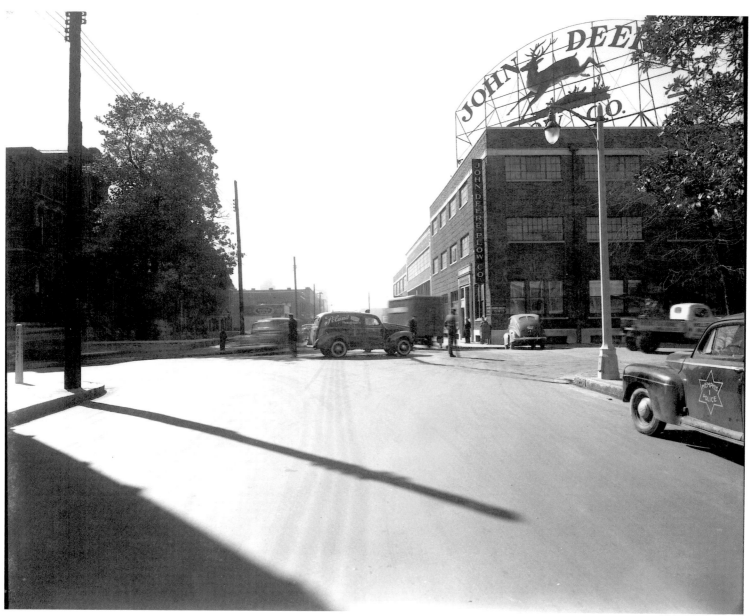

John Deere Company at Front Street and Vance Avenue, 1944.

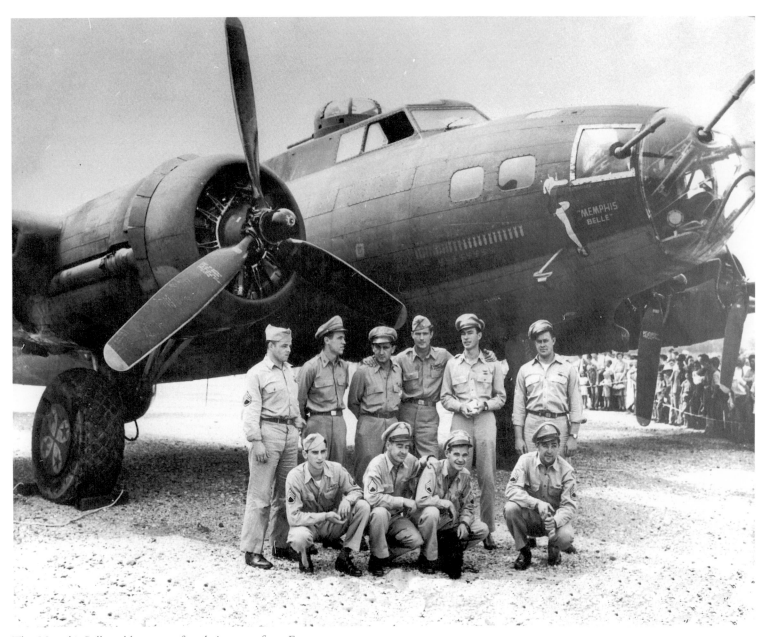

The *Memphis Belle* and her crew after their return from Europe.

Mrs. Christine Parker, who served as librarian for the Mobile Book
Service for the Cossitt Library and Shelby County Libraries, 1947.

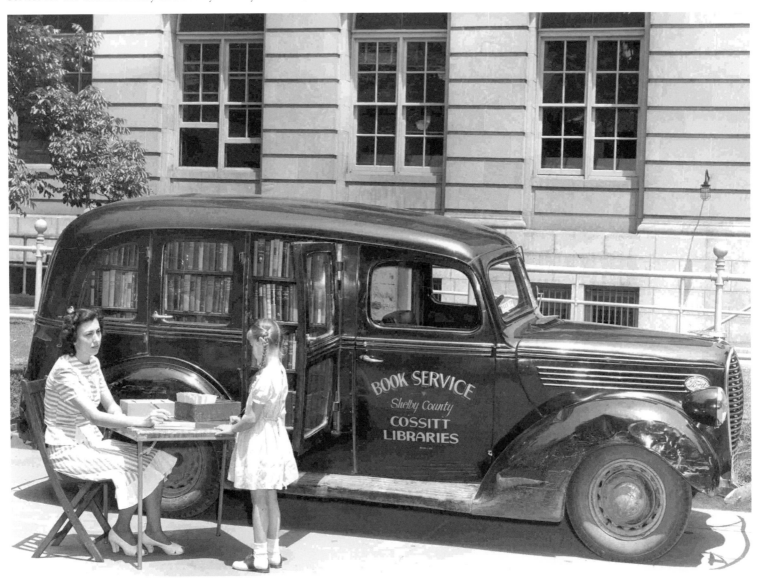

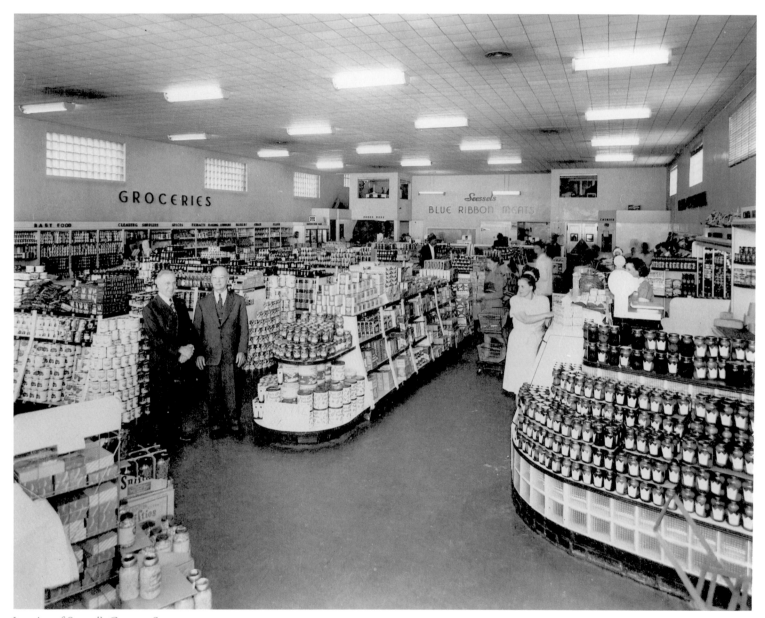

Interior of Seessel's Grocery Store.

Aerial view of the Sterick Building, 1947.

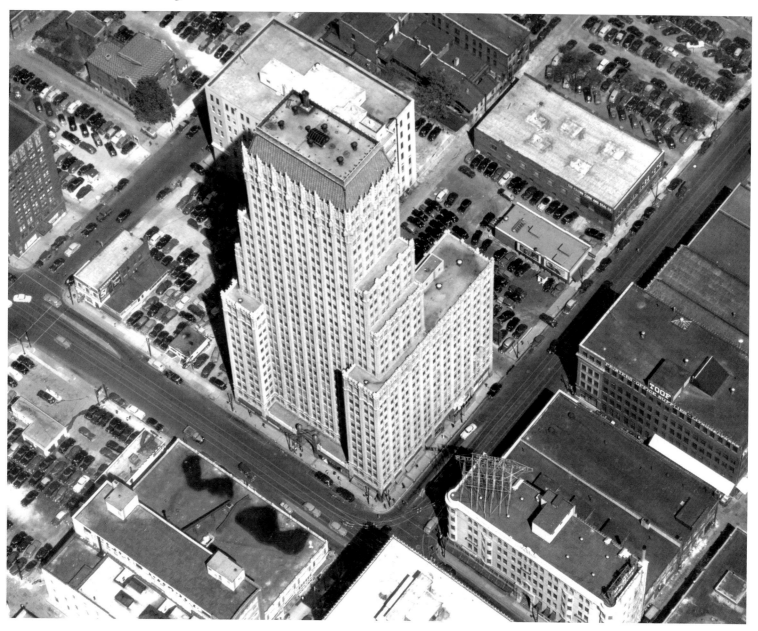

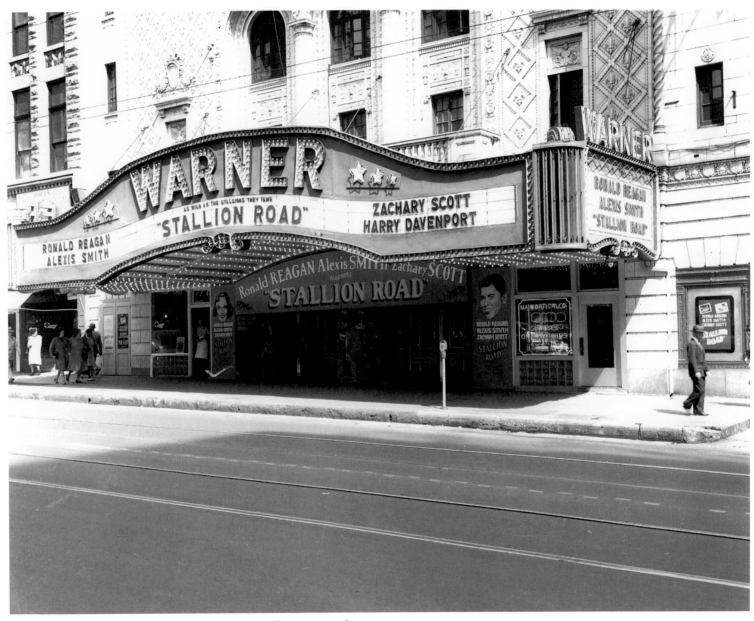

The Warner Theater at 52 South Main Street, 1947. This was one of a
number of theaters in the vicinity including Loew's State, The Strand,
Princess and Loew's Palace.

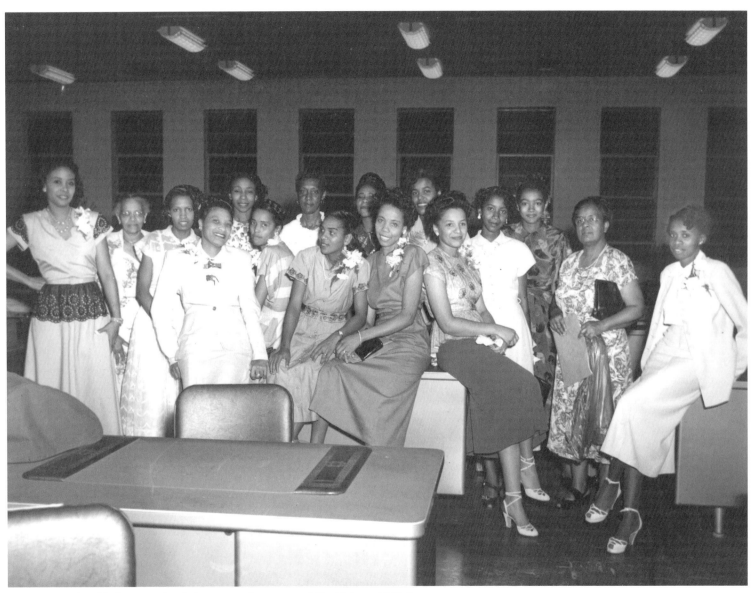

The secretarial staff of Universal Life Insurance Company, 1949. Universal Life Insurance Company was founded by Dr. J.E. Walker in 1923 and operated on the third floor of the Fraternal Bank Building on Beale Street before moving to 234 Hernando in 1930. The company moved again in 1949 into a new building at 480 Linden.

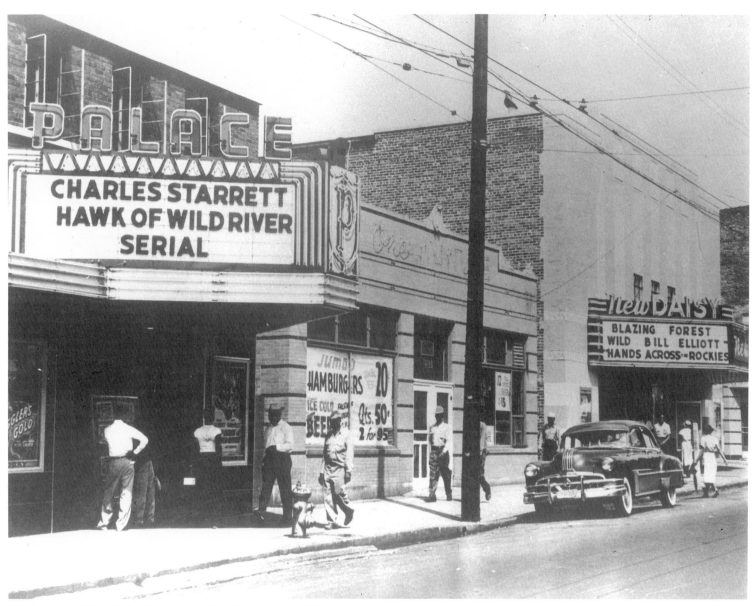

The Palace and New Daisy Theaters on Beale Street, circa 1950.

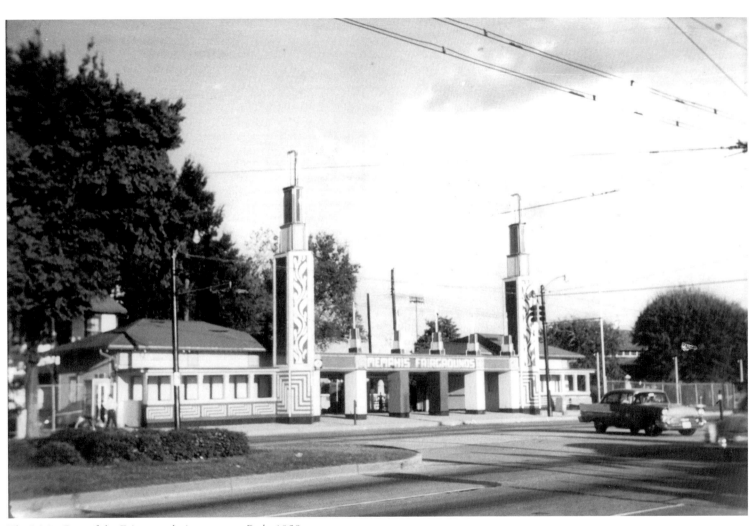

The Main Gate of the Fairgrounds Amusement Park, 1958.

The Pippin Roller Coaster at the Fairgrounds Amusement Park, 1974.

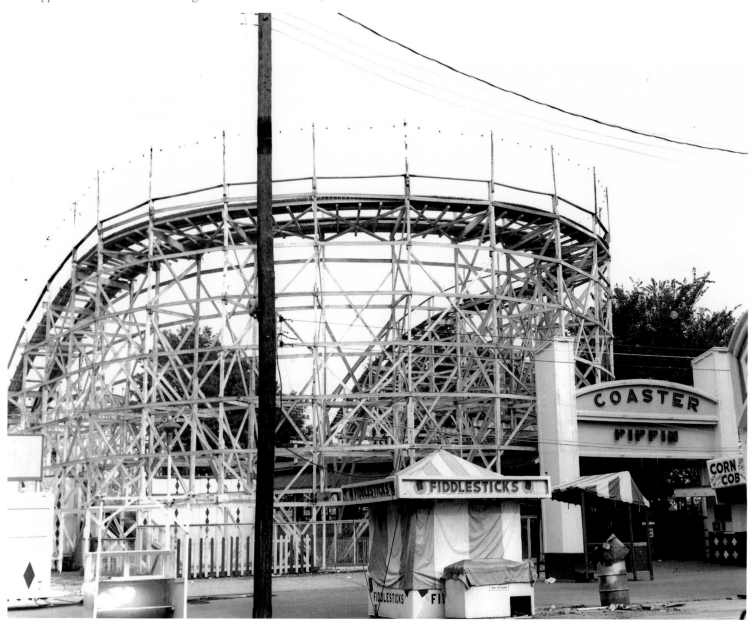

Union Avenue and South Front Street, 1954.

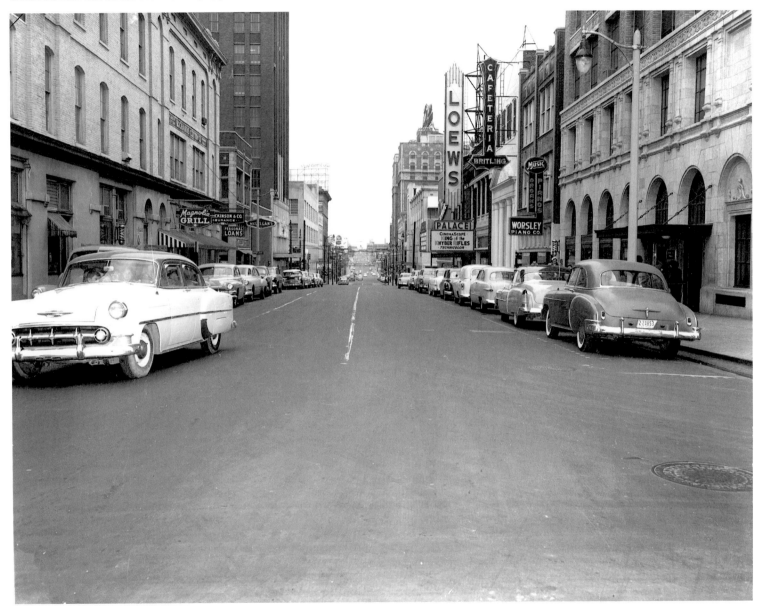

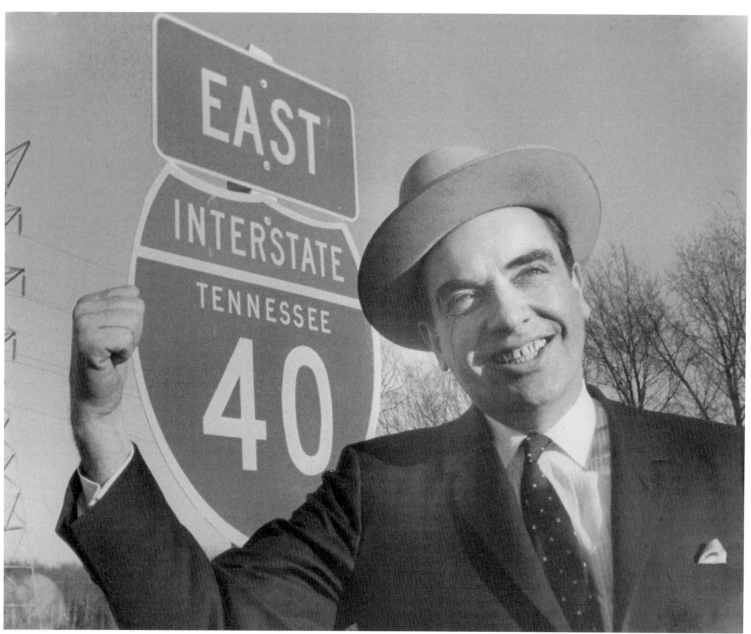

Governor Frank Clement of Tennessee in front of an Interstate 40 sign, circa 1957. I-40 was originally intended to go through Overton Park in Memphis, but public opposition forced the plan to be abandoned. Traffic was rerouted through the northern portion of the I-240 loop, which was redesignated as I-40.

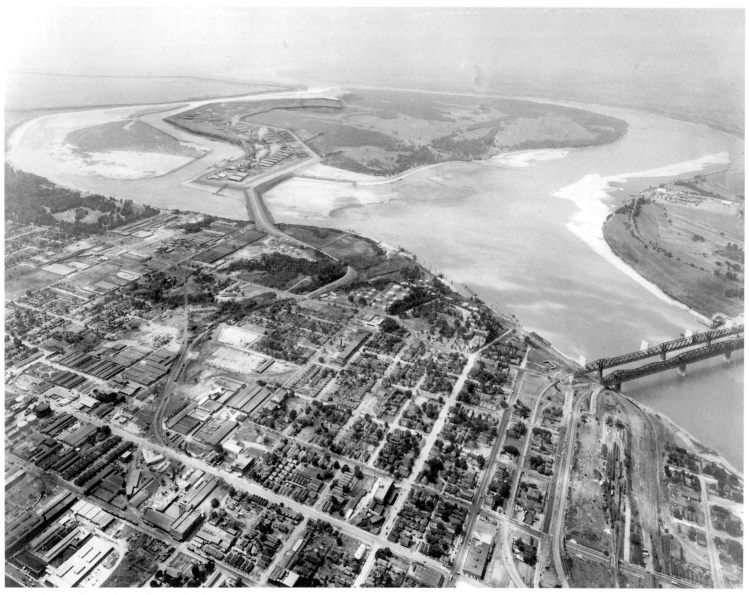

View of Memphis and President's Island, 1948.

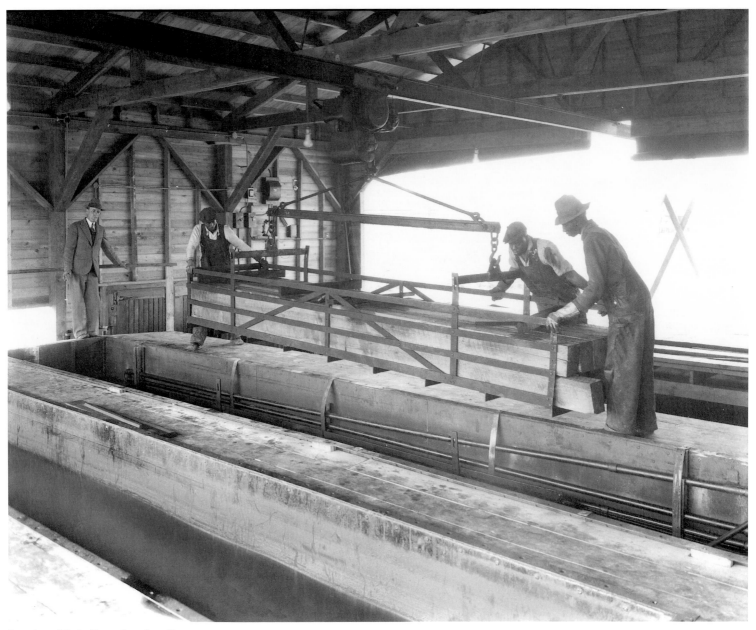

Interior of E. L. Bruce Lumber Company.

Roy Rogers at Ellis Auditorium in 1950.

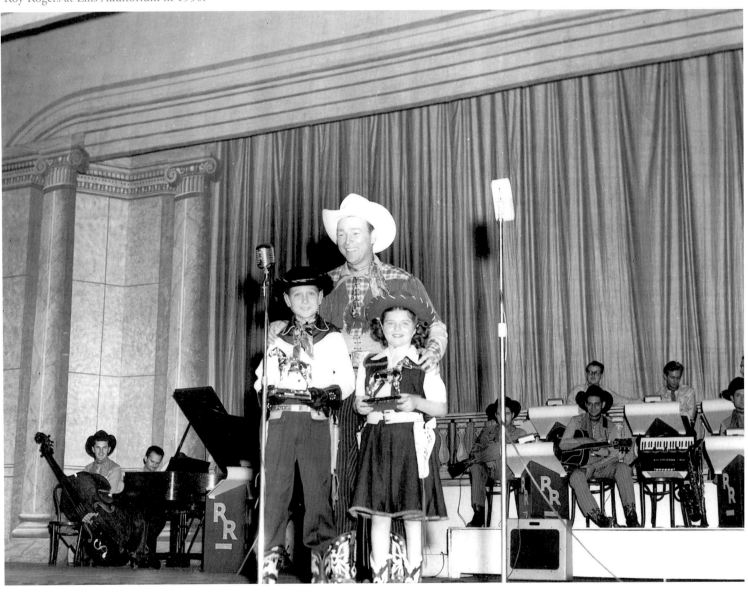

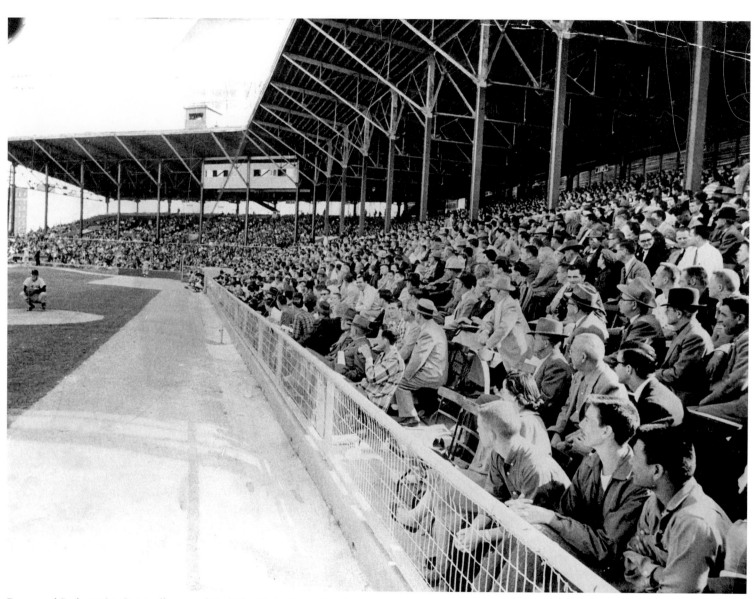

Russwood Park, 1960. Originally named Red Elm Park, the stadium's
name was changed in honor of owner Russell E. Gardner by his son-in-law
Thomas Watkins in 1915. The park was home to the Memphis "Chicks"
baseball team until it was destroyed by fire April 17, 1960.

1960 TO A
MODERN CITY

1960-1983

A struggling actor, Amos Joseph Alphonsus Jacobs, vowed to the patron saint of the hopeless that if he found success, he would build a shrine to him. Jacobs found success and became Danny Thomas. Thomas kept his promise by opening a children's hospital. St. Jude Children's Research Hospital opened in 1962 and became a respected international center for the study and treatment of pediatric illnesses. In its first forty years, the hospital treated over sixteen thousand children from the United States and sixty other countries.

However, a number of events shook Memphis in the 1960's and 1970's. While supporting striking sanitation workers, Dr. Martin Luther King, Jr., was assassinated in Memphis on the balcony of the Lorraine Motel on April 4, 1968. Memphis headlines were dominated by battles regarding school desegregation, the proposal of I-40 going through Overton Park, crime, police corruption and teachers, police officers and firefighters striking. On August 16, 1977, the world's attention was drawn to Memphis again when Elvis Presley died at his home, Graceland.

There were a number of other notable Memphians who made advances as well. Fred Smith created Federal Express in 1972, adding another dimension to the city's role as a distribution center. In 1976, Benjamin L. Hooks was elected executive director of the NAACP. Jesse H. Turner became the first African American to serve as chairman of the Shelby County Board of Commissioners in 1983. Dr. Willie Herenton became the first African American superintendent of the Memphis City Schools in 1979 and later became the first African American to be elected mayor in Memphis.

Memphis suffered from a number of setbacks as it did a century before, but once again, the city not only recovered but thrived. Fortunately, a number of successful efforts were made to improve the conditions of the city and its image. The Memphis in May International Festival began in the 1970s and now features local and national entertainment, international cultural exchange and the World Championship Barbecue Cooking Contest. The renovation of the Peabody Hotel was undertaken in the 1980s. In 1982, the Graceland Museum and the Mud Island Park and River Walk were opened. In 1983, the redeveloped Beale Street opened as a major tourist attraction. The 1990s saw the opening of the Memphis Children's Museum, the Pyramid Arena, the National Civil Rights Museum and a revived trolley system.

Wilson Drug Store at 350 Beale Street, 1964.

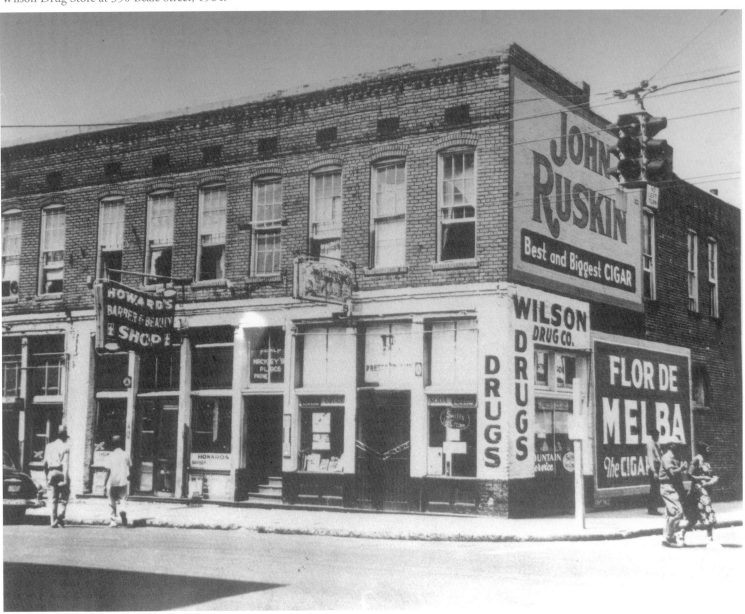

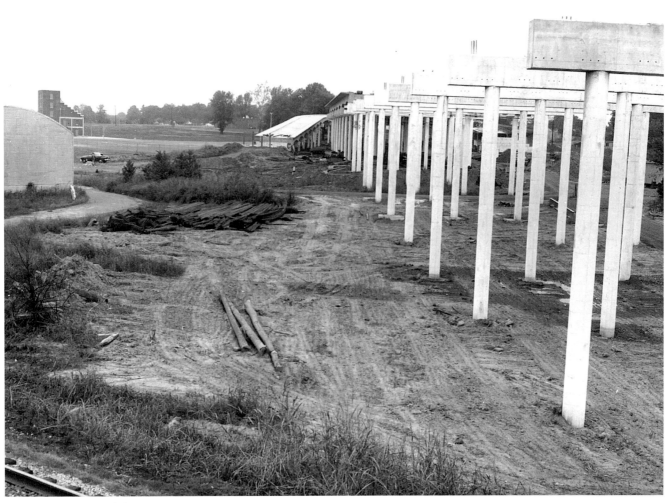

Union Avenue Extended, circa 1961.

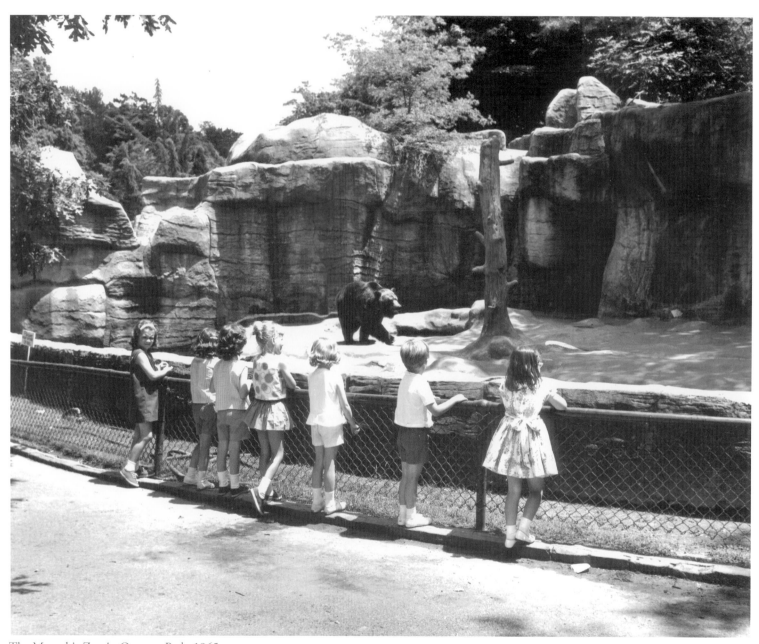

The Memphis Zoo in Overton Park, 1965.

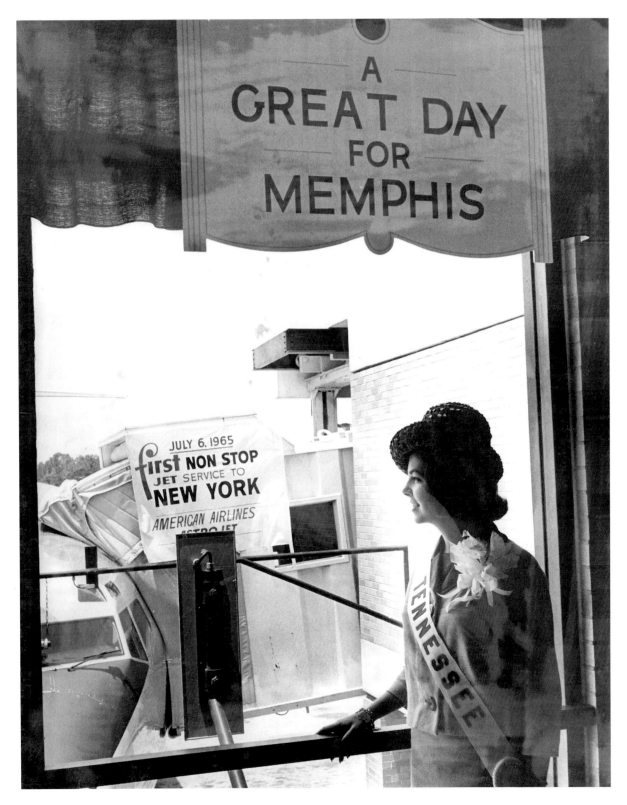

Memphis Metropolitan Airport, 1965. American Airlines offered the first non-stop flight to New York from Memphis beginning July 6, 1965. It was an important step for the airport which at the time was the 27th-busiest in the country.

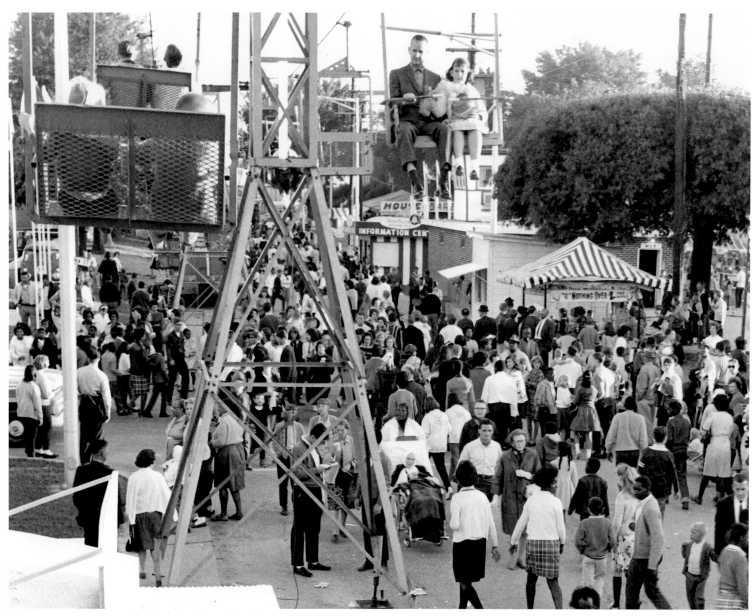

The Mid-South Fair, 1965. The annual Mid-South Fair began in 1856.
The fair runs from late September to early October and features shows,
livestock exhibits, rides and concession stands.

The final stages of construction of City Hall, 1965.

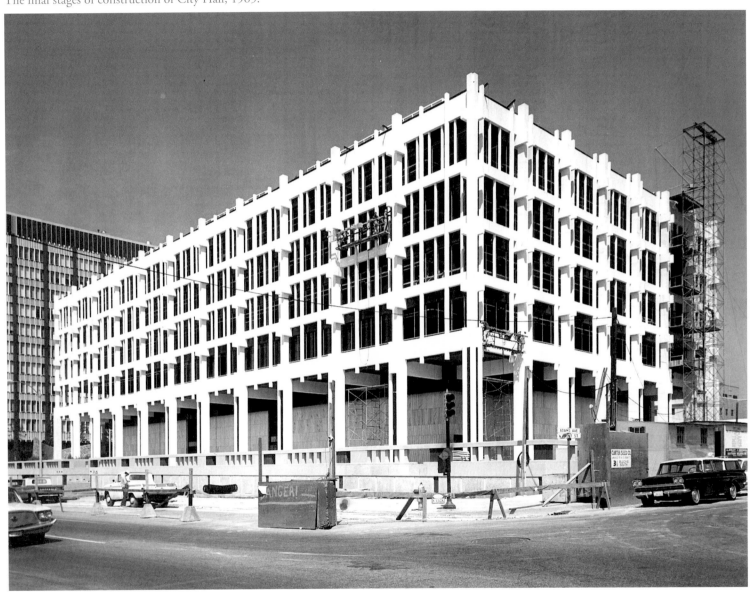

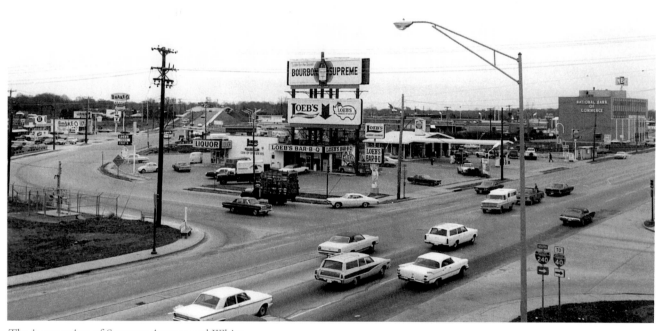

The intersection of Summer Avenue and White
Station Road, 1960s.

The W.C. Handy Monument on Beale Street, 1970s.

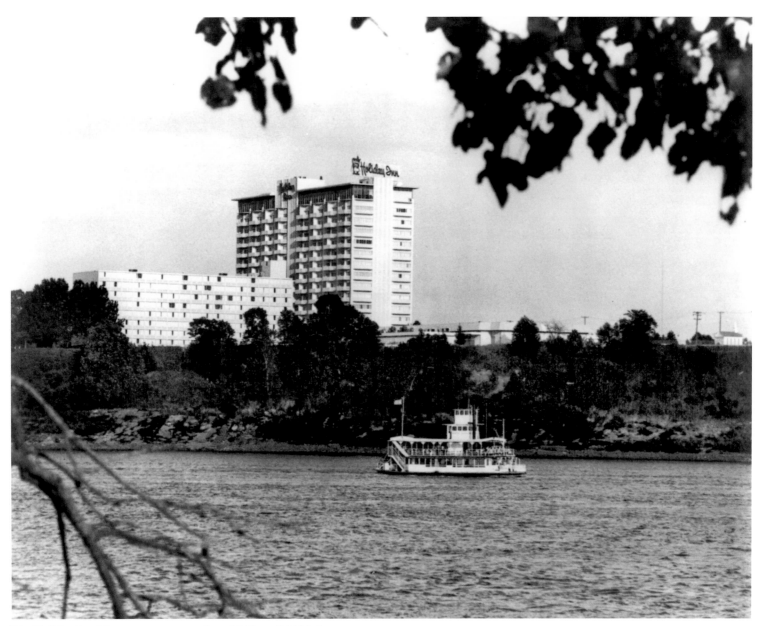

The Holiday Inn Rivermont was open from 1964 until 1984. Its guests
included Walter Mondale, Richard Nixon and the Osmonds. The hotel
was host to a variety of events including dog shows, Cotton Carnival Balls,
boxing matches and NAACP events.

176

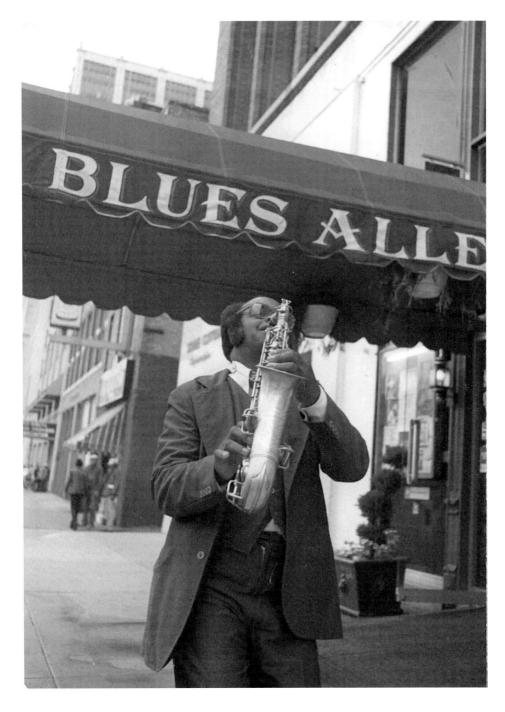

Edward Kirby, a.k.a. Prince Gabe, and his band The Millionaires were known for performing in area night clubs and for leading New Orleans-style funeral processions down Beale Street from the 1960s through the 1980s.

The Schwab family business has been on Beale Street since 1876. Abraham Schwab, pictured here, relocated his dry goods store from 149 to 163 Beale Street in 1912.

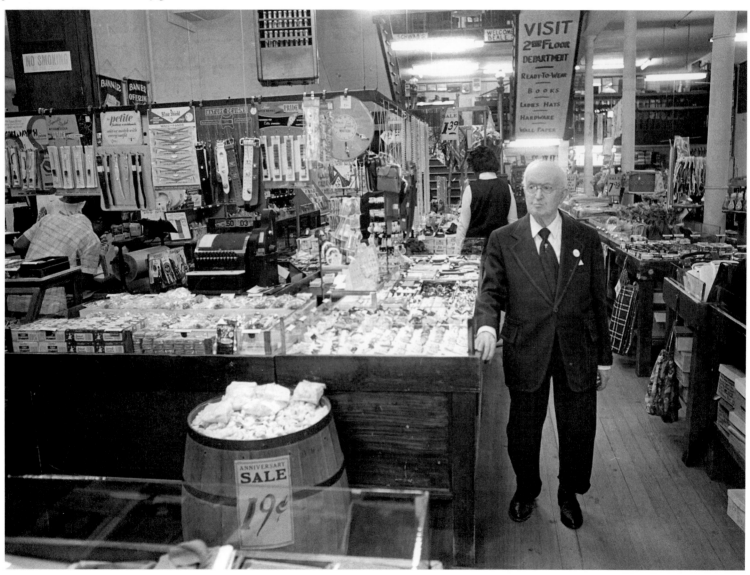

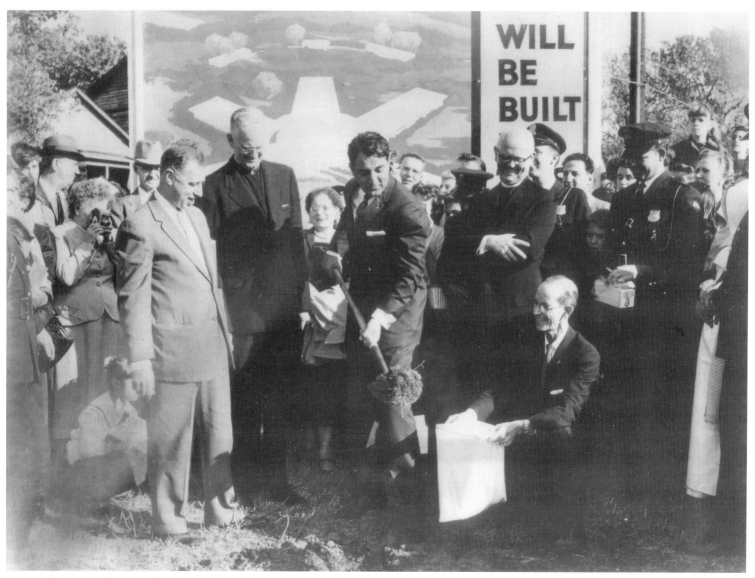

Danny Thomas at the groundbreaking of St. Jude Children's
Research Hospital, 1962.

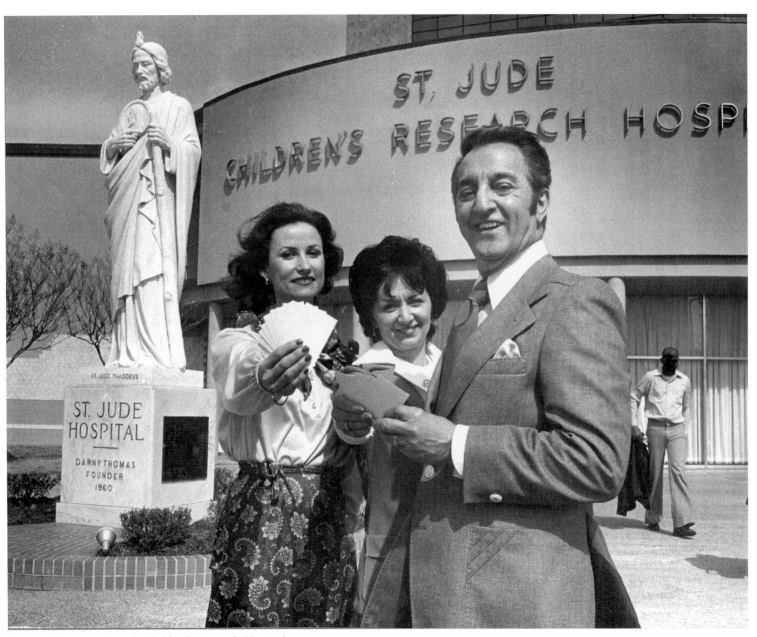

Danny Thomas at St. Jude Children's Research Hospital.

Jackson Mound Park opened in the 1880s and was renamed Desoto Park in 1913. The mound at the back of the picture is known as Chisca's Mound, after a Native American chief encountered by Desoto. The park was named Chickasaw Heritage Park in 1995.

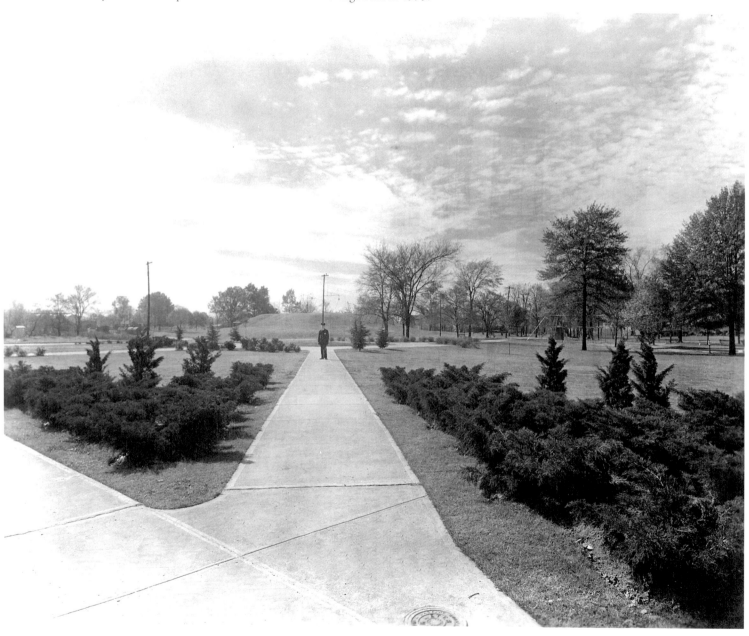

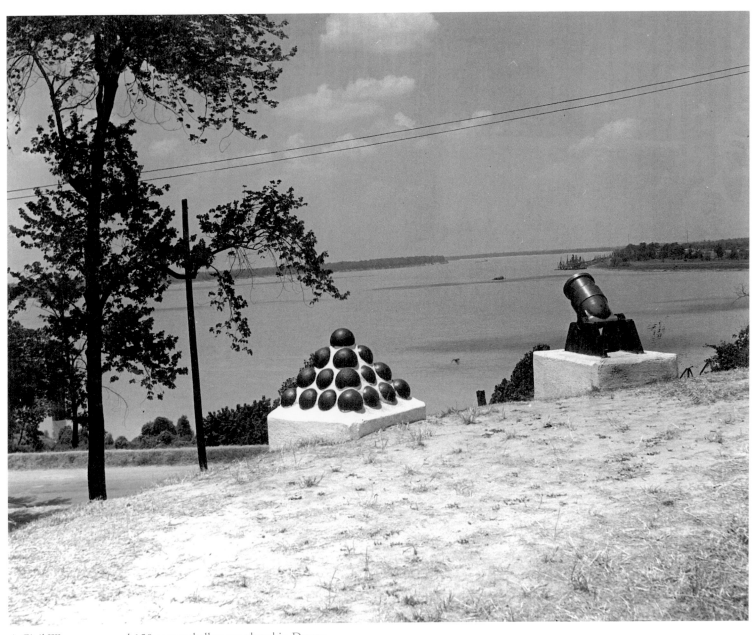

A Civil War cannon and 150 cannonballs were placed in Desoto
Park at the request of Congressman Walter Chandler in 1939.

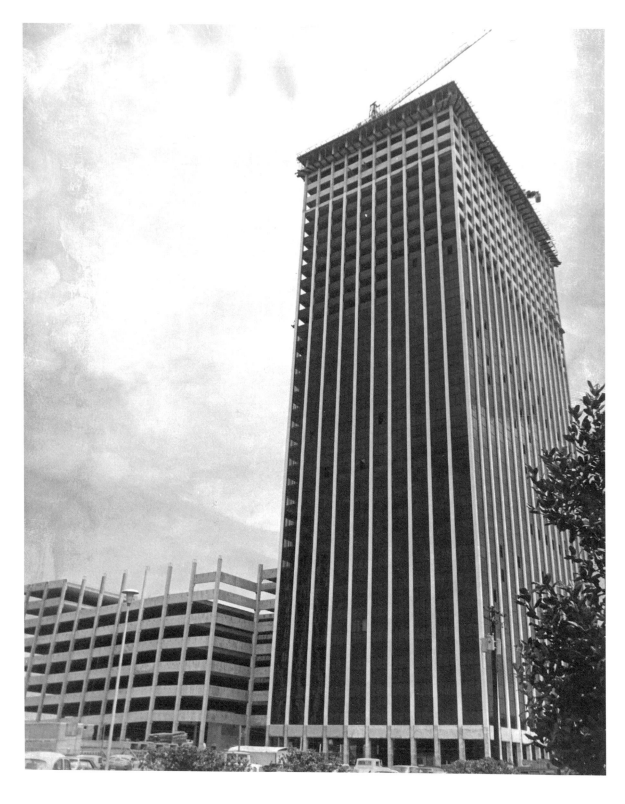

Clark Tower, July 9, 1971. Opened in 1972, The Clark Tower is a 43-floor East Memphis skyscraper named after developer William Benjamin Clark.

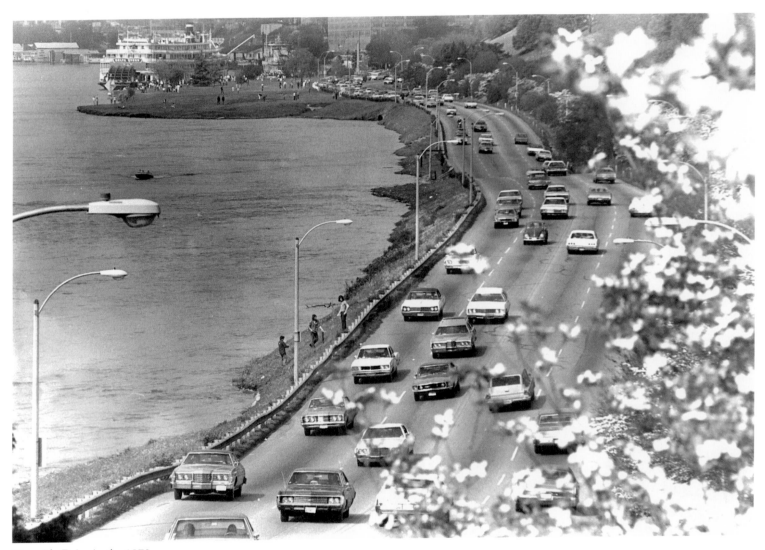

Riverside Drive in the 1970s.

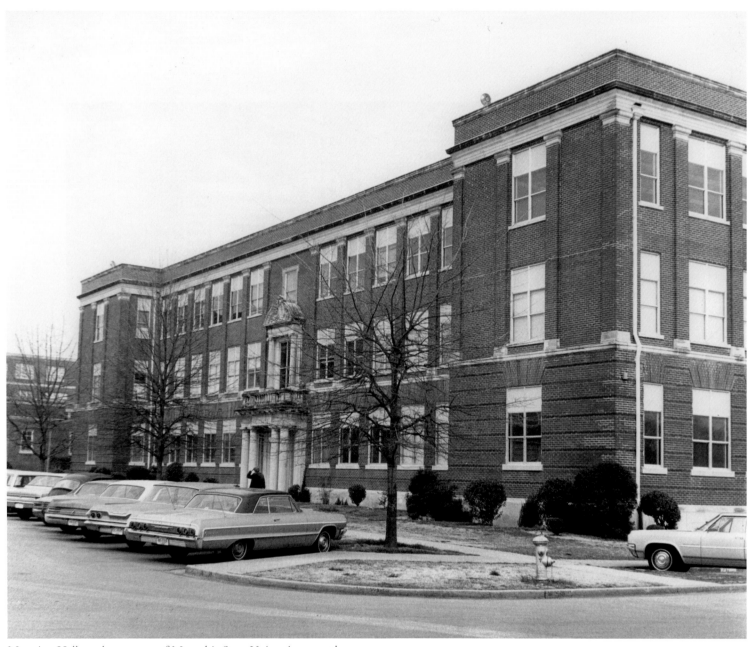

Manning Hall on the campus of Memphis State University, now the
University of Memphis, 1968.

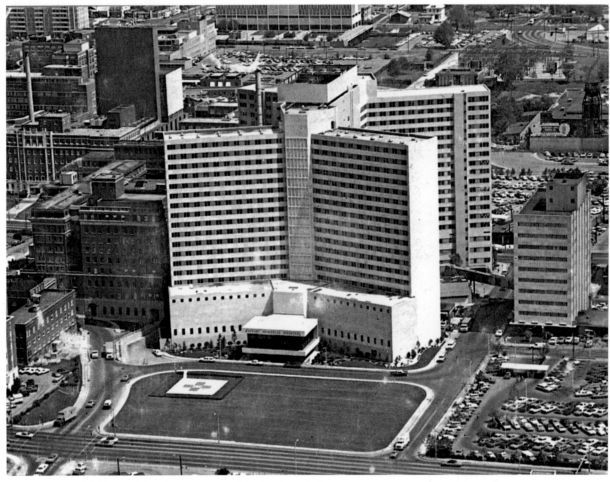

Baptist Memorial Hospital was first constructed in 1955,
and an addition was made in 1967. The hospital was
demolished in November 2005.

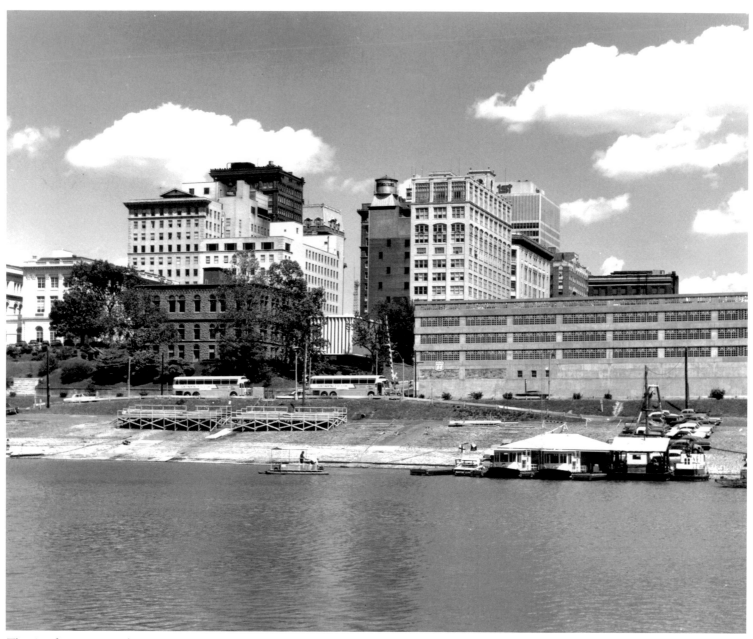

The riverfront at Memphis, 1969.

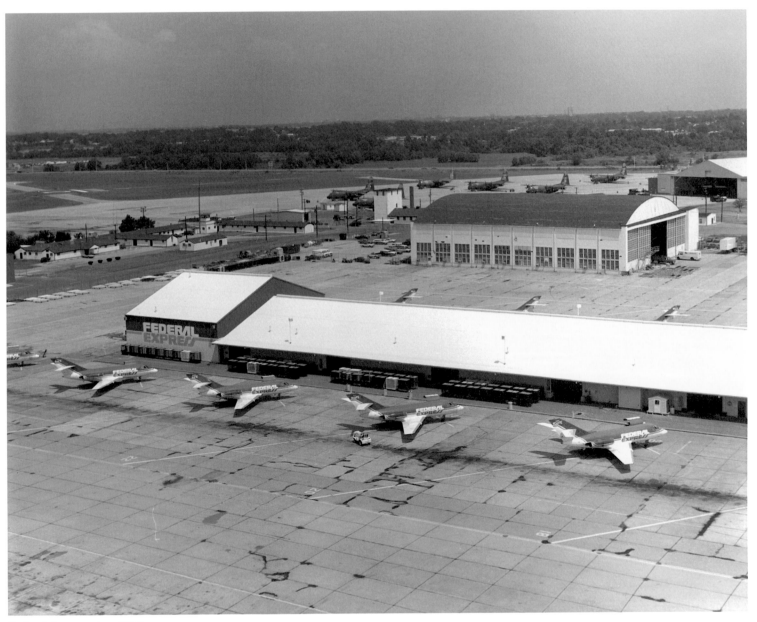

Federal Express, circa 1974.

NOTES ON THE PHOTOGRAPHS

These notes, listed by page number, attempt to include all aspects known of the photographs. Each of the photographs are identified by the page number, photograph's title or description, photographer/collection, archive and call or box number when applicable. While every attempt was made to collect all available data, in some cases complete data was unavailable due to the age and condition of some of the photographs and records.

II **KING COTTON**
Memphis Public Library
Memphis and Shelby County Room
Photo by John C. Coovert

VI **SHELBY CO. COURTHOUSE LAW LIBRARY**
Memphis Public Library
Memphis and Shelby County Room
2359C 1147

2 **HOME OF JAMES MONROE WILLIAMSON**
Tennessee State Library and Archives
Collection
Drawer 14, Folder 130

3 **HUNT-PHELAN HOUSE**
Memphis Public Library
Memphis and Shelby County Room
Historic American Buildings Survey

4 **SULTANA**
Memphis Public Library
Memphis and Shelby County Room
5109C 6188

5 **FREDRICK COSSITT**
Memphis Public Library
Memphis and Shelby County Room
1881C 168
Contributed by W.E.D. Stokes, Jr.

6 **MEMPHIS BOAT CLUB**
Memphis Public Library
Memphis and Shelby County Room
Gift of Dr. J.C. Woosley
5613C 3769

7 **OLD STEAM DUMMY**
Memphis Public Library
Memphis and Shelby County Room
617C 4393
Copy furnished by W.R. McKay

8 **N.W. CORNER OF MAIN AND JEFFERSON**
Memphis Public Library
Memphis and Shelby County Room
7717C 1578

9 **GOLDSMITH & BROS.**
Memphis Public Library
Memphis and Shelby County Room
6978S

10 **FRISCO BRIDGE**
Memphis Public Library
Memphis and Shelby County Room
4523C 1297
Apply for copies to Pink Palace
Accession no. 1961.12.272/68c

11 **FRISCO BRIDGE**
Memphis Public Library
Memphis and Shelby County Room
6052NC 1337

159 FAIRGROUNDS AMUSEMENT PARK
Memphis Public Library
Memphis and Shelby County Room
613C 4487
Gift from John M. Caruthers

160 FAIRGROUNDS AMUSEMENT PARK
Memphis Public Library
Memphis and Shelby County Room
665C 5316
Gift of Donne Walden

161 UNION AVE AND S FRONT ST
Memphis Public Library
Memphis and Shelby County Room
6787NC 4976

162 GOVERNOR FRANK CLEMENT
Memphis Public Library
Memphis and Shelby County Room
773C 465
Picture Credit: Commercial Appeal

163 PRESIDENT'S ISLAND, AERIAL VIEW
Memphis Public Library
Memphis and Shelby County Room
8028C 1396
From the Fowler Collection

164 E. L. BRUCE LUMBER COMPANY
Memphis Public Library
Memphis and Shelby County Room
5825NC 951
Photo by Poland

165 ROY ROGERS AT ELLIS AUDITORIUM
Memphis Public Library
Memphis and Shelby County Room
6256N

166 RUSSWOOD PARK, 1960
Memphis Public Library
Memphis and Shelby County Room
6152C 4584
Gift of John Guinozzo

168 WILSON DRUG STORE
Memphis Public Library
Memphis and Shelby County Room
6092NC 379

169 UNION AVENUE EXTENDED
Memphis Public Library
Memphis and Shelby County Room
8349C 5604
Gift of Mr. and Mrs. James R. Webb in
honor of Lisa Hilary Webb

170 OVERTON PARK ZOO
Tennessee State Library and Archives
Department of Conservation
Photograph Collection
Box 16, File 123, Accession No. RG 82,
Negative # CV9916

171 AMERICA AIRLINES
Memphis Public Library
Memphis and Shelby County Room
724C 1258

172 MID-SOUTH FAIR, 1965
Memphis Public Library
Memphis and Shelby County Room
7435C 4421

173 CITY HALL, 1965
Memphis Public Library
Memphis and Shelby County Room
8688

174 SUMMER AVE AND WHITE STATION RD
Memphis Public Library
Memphis and Shelby County Room
8309C 5540
Gift of Mr. and Mrs. James R. Webb in
honor of Lisa Hilary Webb

175 W. C. HANDY MONUMENT
Memphis Public Library
Memphis and Shelby County Room
7171C 238
Duplicate print from the urban Renewal
Files

176 HOLIDAY INN RIVERMONT
Memphis Public Library
Memphis and Shelby County Room
6348C 3022
Gift of Holiday Inn Rivermont

177 EDWARD KIRBY, A.K.A. PRINCE GABE
Memphis Public Library
Memphis and Shelby County Room
7325
Gift of Ed Cooper

178 A. SCHWAB
Memphis Public Library
Memphis and Shelby County Room
8227C 6515
Gift of Saul Brown

179 ST. JUDE GROUNDBREAKING
Memphis Public Library
Memphis and Shelby County Room

180 DANNY THOMAS AT ST. JUDE'S RESEARCH CENTER
Memphis Public Library
Memphis and Shelby County Room
8082C 6408
Gift of Saul Brown

181 DESOTO PARK
Memphis Public Library
Memphis and Shelby County Room
3732C 4341
From the Municipal Reference Library

182 DESOTO PARK
Memphis Public Library
Memphis and Shelby County Room
3336C 7261
From the Municipal Reference Library

183 **CLARK TOWER**
Memphis Public Library
Memphis and Shelby County Room
7076C 4429

184 **RIVERSIDE DRIVE**
Memphis Public Library
Memphis and Shelby County Room
30149C 5033
Gift of Saul Brown

185 **REMODELED MANNING HALL**
Tennessee State Library and Archives
Library Collection
Drawer 14, Folder 105;
Image Number: 2746

186 **BAPTIST MEMORIAL**
HOSPITAL
Memphis Public Library
Memphis and Shelby County Room
777C 3108

187 **THE WATERFRONT AT**
MEMPHIS
Tennessee State Library and Archives
Department of Conservation
Photograph Collection
Box 16, File 146; Accession No. RG 82;
Image No. 15815

188 **FEDERAL EXPRESS**
Memphis Public Library
Memphis and Shelby County Room

198 **MEMPHIS IN MAY**
Memphis Public Library
Memphis and Shelby County Room
Gift of Saul Brown

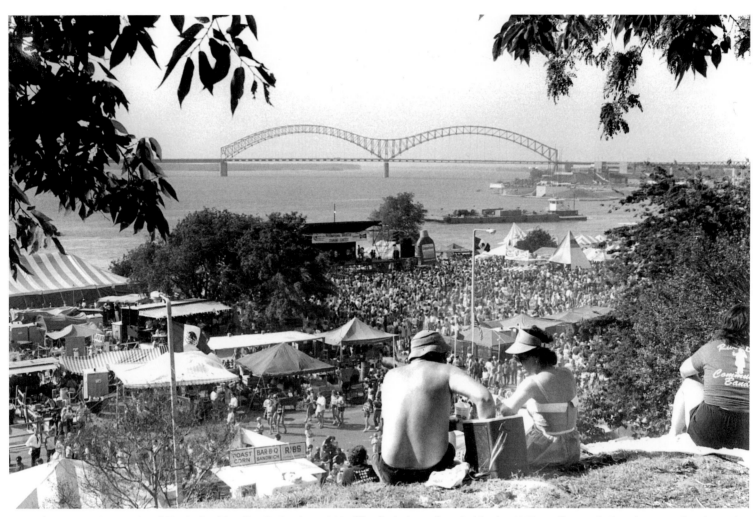

Memphis in May International Festival at Tom Lee Park, circa 1980. The festival was founded in the 1970s to foster relations between the city and foreign countries. Each year, the festival honors a specific country and includes educational programs, the Beale Street Music Festival, the Sunset Symphony and the World Championship Barbeque Cooking Contest.